COOL SHOPS
TOKYO

teNeues

Imprint

Editor: Llorenç Bonet

Editorial assistant: Maia Francisco

Photography: Nacása & Partners, Daici Ano (pages 34-37 and pages 92-95), Kozo Takayama (pages 104-107)

Introduction: Llorenç Bonet

Layout & Pre-press: Ignasi Gracia Blanco

Translations: Matthew Clarke (English), Susanne Engler (German), Michel Ficerai/Lingo Sense (French), Maurizio Siliato (Italian)

Produced by Loft Publications
www.loftpublications.com

Published by teNeues Publishing Group

teNeues Book Division
Kaistraße 18
40221 Düsseldorf, Germany
Tel.: 0049-(0)211-994597-0
Fax: 0049-(0)211-994597-40
E-mail: books@teneues.de

Press department:
arehn@teneues.de
Phone: 0049-2152-916-202

www.teneues.com

teNeues Publishing Company
16 West 22nd Street
New York, NY 10010, USA
Tel.: 001-212-627-9090
Fax: 001-212-627-9511

teNeues Publishing UK Ltd.
P.O. Box 402
West Byfleet
KT14 7ZF, Great Britain
Tel.: 0044-1932-403509
Fax: 0044-1932-403514

teNeues France S.A.R.L.
4, rue de Valence
75005 Paris, France
Tel.: 0033-1-55 76 62 05
Fax: 0033-1-55 76 64 19

teNeues Iberica S.L.
Pso. Juan de la Encina 2-48,
Urb. Club de Campo
28700 S.S.R.R. Madrid, Spain
Tel./Fax: 0034-91-659 58 76

ISBN-10: 3-8327-9122-1
ISBN-13: 978-3-8327-9122-3

Bibliographic information published by Die Deutsche Bibliothek.
Die Deutsche Bibliothek lists this publication in the Deutsche Nationalbibliografie;
detailed bibliographic data is available in the Internet at http://dnb.ddb.de.

Contents

Page

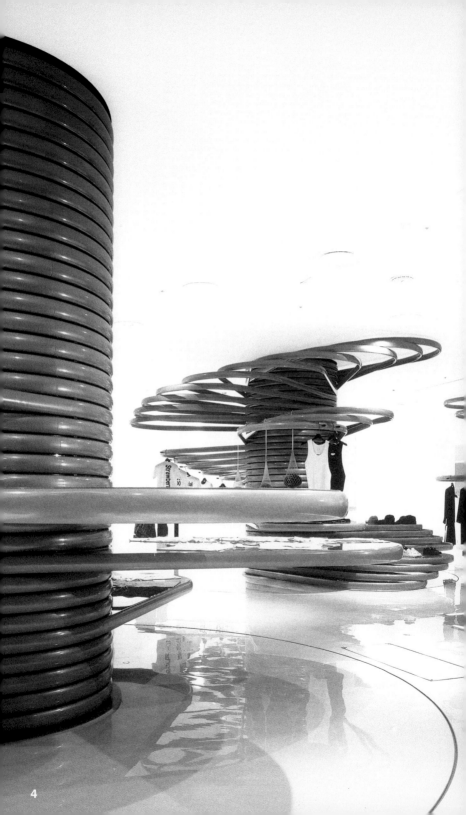

roduction

Tokyo, the capital of one of the most centralized countries in the world,
itical power rubs shoulders with multinationals and the majority of Japan's
ustries. The dense concentration of towering office blocks, official buildings
1 homes has made space one of the greatest signs of wealth. So, the sur-
e area of a store and its location within the city are two of the factors that
/e the greatest impact on the public's assessment of it. What is most strik-
about Tokyo's stores, however, is the sobriety of their design: even the
st elaborate ones retain a simple, minimalist feel and are subject to a spa-
organization governed by orderliness and austerity. The simplicity and
nsparency of commercial spaces is directly related to the emergence of a
balized popular culture. Whereas once the Japanese culture assimilated for-
n trends and made them their own, now Tokyo begins to exert a great influ-
ce on the rest of the world, exporting its leisure and entertainment.
hough the differences between Japan and the West have become dramati-
ly less marked in the last twenty-five years, the former has maintained its
)syncrasy, although the idea that doing business in Japan means having to
apt a brand's design to the specific characteristics of the Orient is no longer
olicable. Therefore, it is fairly commonplace to find not only European and
ierican brands in Tokyo, but also architects and designers from these two
ntinents working there.
kyo is a trendsetter among the network of interconnected cities that has
en formed by the great capitals of the globalized world. The dynamism and
ality of the city center are worthy of a metropolis in which every day millions
people go shopping, eat or relax in the scarce leisure time left to them after
iking their contribution to keeping the city up and running.

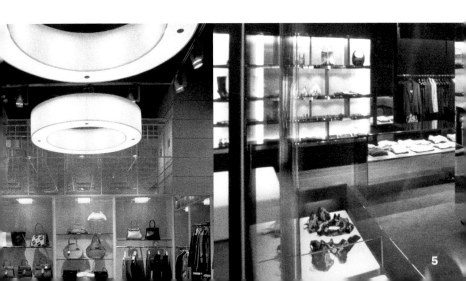

Einleitung

Tokio, die Hauptstadt eines der zentralistischsten Länder der Welt, ist als po
tischer und industrieller Mittelpunkt Japans auch Hauptanziehungspunkt für
japanischen Niederlassungen internationaler Unternehmen. Die daraus resul
tierende extreme Konzentration von Wolkenkratzern voller Büros, von offiziel
Gebäuden und Privatwohnungen macht hier Platz an sich zu einem Zeichen f
Reichtum. Die bestimmenden Faktoren für die Bewertung eines Ladens sind
den Augen der Öffentlichkeit deswegen neben seiner Lage in der Stadt die
Anzahl seiner Quadratmeter. Dennoch fällt auf, wie schlicht die Geschäfte
Tokios gestaltet sind. Sogar die luxuriöser ausgestatteten Läden wirken mini
malistisch und einfach, und ihre räumliche Gestaltung ist geordnet und zurüc
haltend. Diese Einfachheit und Klarheit hat nichts mehr gemein mit dem alt-
hergebrachten Vorurteil über eine japanische Kultur, die ausländische Einflüs
se aufnimmt und sich einverleibt, sondern ist vielmehr Bestandteil einer glob
len Kultur, die heutzutage von Tokio und seinem Freizeitverhalten wesentlich
beeinflusst wird.
Obwohl sich die Unterschiede zwischen Japan und den westlichen Ländern ir
den letzten fünfundzwanzig Jahren drastisch verringert haben, hat es das La
verstanden, sich seine Eigenarten zu bewahren. Die Vorstellung, dass sich
jede Marke an das im Osten übliche Design anpassen muss, um hier Erfolg
haben, hat jedoch keine Gültigkeit mehr. Deshalb ist es auch nicht verwunde
lich, dass man in Tokio nicht nur europäische und amerikanische Marken fin-
det, sondern auch Architekten und Designer aus diesen Kontinenten, die in
der Hauptstadt Japans arbeiten.
Unter den eng miteinander verzahnten Großstädten unserer globalisierten We
kann Tokio als einer der Trendsetter gelten. Die Dynamik und Kraft seines
Stadtzentrums ist einer Metropole würdig, in der Millionen von Menschen Tag
für Tag ihre Einkäufe machen, essen gehen oder sich in der knapp bemesse-
nen Freizeit entspannen, die ihnen bleibt, nachdem sie ihren Beitrag dazu
geleistet haben, dass Handel und Gewerbe ihrer Stadt weiterhin boomen.

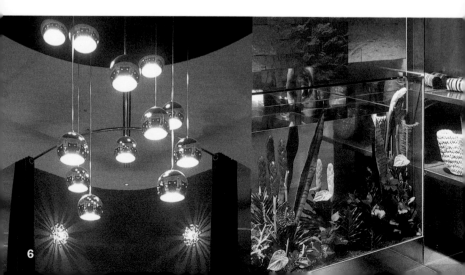

ntroduction

Tokyo, la capitale d'un des pays les plus centralisés du monde, le pouvoir litique cohabite avec les entreprises internationales et les industries majeu- s du pays. La grande agglomération de gratte-ciel de bureaux, de bâtiments ficiels et de logements a converti l'espace en l'un des signes de richesse r excellence. De ce fait, les mètres carrés d'un établissement et sa situa- n dans la ville constituent deux facteurs déterminants pour valoriser le lieu x yeux du public. Toutefois, les boutiques à Tokyo attirent essentiellement ttention par la sobriété de leur design : même les plus surchargées arbo- nt un air minimaliste et simple et disposent de quelques paramètres d'orga- sation de l'espace qui voient prédominer l'ordre et la modération. Cette sim- cité et cette clarté des espaces commerciaux n'a plus rien en commun avec préjugé suranné selon lequel la culture japonaise assimilerait toute influen- étrangère pour la faire sienne, mais est au contraire liée à l'apparition une culture populaire globale sur laquelle Tokyo exerce une grande influence vers laquelle elle exporte sa culture des loisirs et des divertissements. en que les différences entre le Japon et les pays occidentaux aient diminué manière drastique au cours des vingt cinq dernières années, le pays a pré- rvé son idiosyncrasie. Pour autant, l'idée selon laquelle la conquête de l'île clame d'adapter le design d'une marque aux spécificités de l'Orient a fait ng feu : de la sorte, il n'est pas inaccoutumé de trouver à Tokyo non seule- ent les marques européennes et américaines, mais aussi des architectes et s créateurs de ces deux continents travaillant dans la capitale nippone. kyo est une ville leader en termes de tendances au cœur de l'ensemble des tés interconnectées qui se sont érigées dans les grandes capitales d'un onde globalisé. Le dynamisme et la vitalité du centre de la ville sont propres s métropoles, où chaque jour des millions d'êtres font leurs achats, man- nt ou se détendent pendant les brefs instants restants après avoir contribué maintenir la ville à sa place.

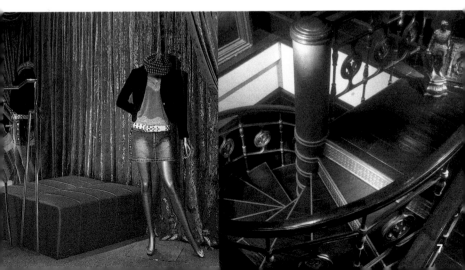

Introducción

En Tokio, la capital de uno de los países más centralizados del mundo, el poder político convive con las empresas internacionales y con la mayoría de las industrias del país. La gran aglomeración de rascacielos de oficinas, edificios oficiales y viviendas ha convertido el espacio en uno de los mayores signos de riqueza. Por este motivo, los metros cuadrados de un establecimiento y su ubicación dentro de la ciudad son dos de los factores que más influyen en su valoración por parte del público. Sin embargo, lo que más llama la atención de las tiendas de Tokio es la sobriedad de su diseño: incluso las más recargadas tienen un aire minimalista y sencillo, y disponen de unos parámetros de organización espacial en los que predomina el orden y la moderación. La sencillez y claridad de los espacios comerciales está directamente relacionada con la aparición de una cultura popular global. Si bien hasta hace poco la cultura japonesa asimilaba las modas extranjeras y las convertía en algo propio, actualmente Tokio empieza a ejercer una gran influencia en el resto del mundo, a quien exporta su cultura del ocio y del entretenimiento.

Aunque las diferencias entre Japón y los países occidentales han disminuido drásticamente en los últimos veinticinco años, este país ha sabido mantener su idiosincrasia. Sin embargo, la idea de que para entrar en la isla hay que adaptar el diseño de una marca a las especificidades de Oriente ha desaparecido: por eso no es extraño encontrar en Tokio no sólo marcas europeas y americanas, sino también arquitectos y diseñadores de estos dos continentes que trabajan en la capital nipona.

Tokio es una ciudad líder en tendencias dentro del conjunto de ciudades interconectadas que se han erigido en las grandes capitales del mundo globalizado. El dinamismo y la vitalidad del centro de la ciudad son propios de las vastas metrópoli, donde cada día millones de personas hacen sus compras, comen o se relajan durante el escaso tiempo de ocio que les queda después de contribuir a poner la ciudad en pie.

troduzione

Tokyo, la capitale di uno dei paesi più centralizzato al mondo, il potere politi-
convive con le grandi multinazionali e la maggior parte delle industrie nippo-
he. Il grande addensamento di grattacieli, occupati da uffici, enti ufficiali e
itazioni private, ha trasformato lo spazio in uno dei maggiori segni di ricchez-
. Per questo motivo, i metri quadrati di un qualsiasi locale e la sua posizione
'interno della città sono due dei fattori che più incidono sulla valutazione del
sto da parte del pubblico. Nonostante ciò, i negozi di Tokyo sorprendono per
sobrietà del loro disegno. Persino quelli dall'arredamento sovraccarico pre-
ntano un'atmosfera semplice e minimalista, con dei parametri di organizza-
ne spaziale in cui predomina l'ordine e la sobrietà. La semplicità e la chia-
zza tipiche degli spazi commerciali è legata alla comparsa di una cultura
polare globale. Sebbene fino poco tempo fa la cultura giapponese assimila-
le mode straniere facendole proprie, attualmente Tokyo inizia a esercitare
a gran influenza sul resto del mondo, verso cui esporta la sua cultura dello
ago e dell'intrattenimento.
bbene le differenze tra il Giappone e i paesi occidentali siano diminuite dra-
camente negli ultimi venticinque anni, questo paese ha mantenuto la pro-
a idiosincrasia. L'idea in base a cui per entrare nel mercato nipponico biso-
a adattare il design di un marchio alle specifiche caratteristiche dell'Oriente
rmai scomparsa. Per questo non è strano trovare a Tokyo non solo marchi
ropei ed americani ma anche architetti e designer di questi continenti che
orano nella capitale nipponica.
kyo è una città leader all'interno della rete che connette le grandi capitali
l mondo globalizzato. Il dinamismo e la vitalità del centro sono quelle delle
andi metropoli, in cui ogni giorno milioni di persone vanno a fare shopping,
anzano o fanno una pausa nei pochi ritagli di tempo che gli rimangono dopo
er contribuito a mantenere in piedi la città.

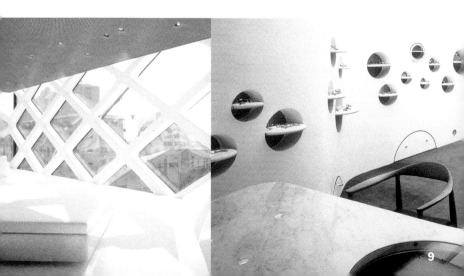

Aprica
Design: Aprica

F-102, Hillside Terrace, 18-8 Sarugaku-cho I Tokyo 150-0033 I Shibuya-ku
Phone: +81 3 5728 8760
www.apricausa.com
Subway: Daikanyama
Opening hours: Tue–Sun 11 am to 7 pm
Products: Baby strollers and carriages
Special features: The most contemporary designs for tiny tots

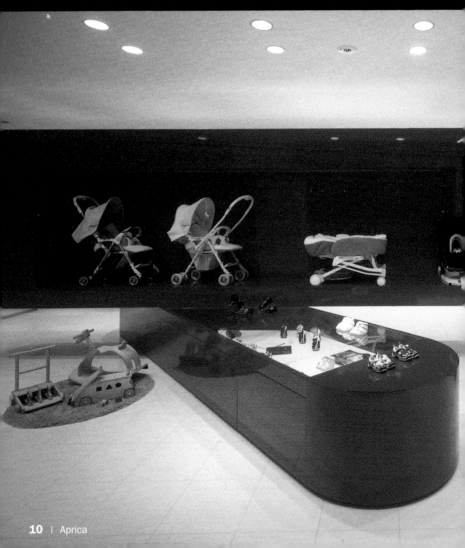

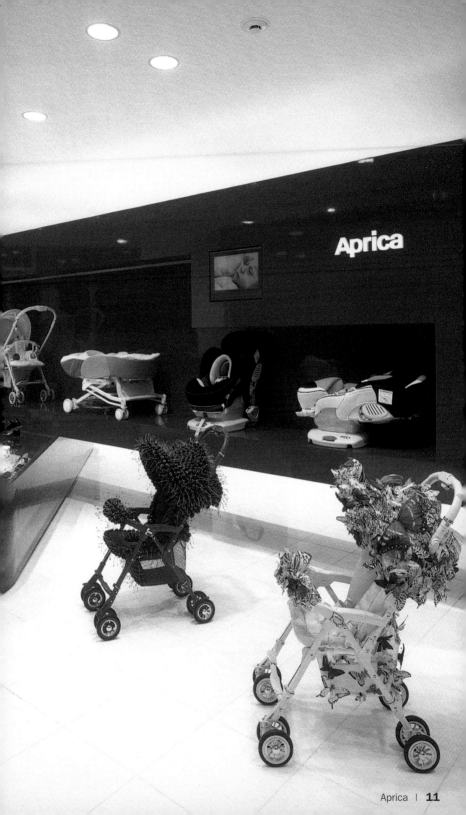

Aprica | **11**

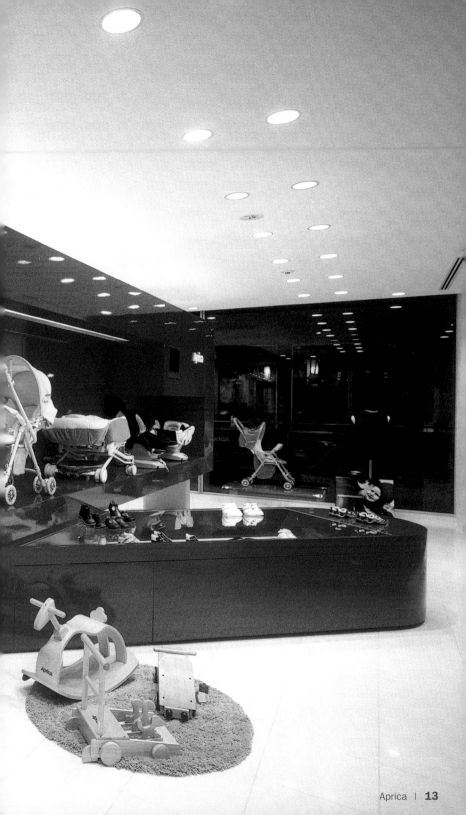

Aveda Lifestyle
Salon & Spa

Design: FRCH Design Worldwide | Architect: Masao Murakami

5-5-21 Minami-Aoyama | Tokyo 107-0062 | Minato-ku
Phone: +81 3 5468 5800
www.aveda.com
Subway: Omotesando
Opening hours: Mon–Fri 11 am to 8 pm, Sat 10 am to 8 pm, Sun 10 am to 7 pm
Products: Cosmetics for a lifestyle grounded in wellness and environmental responsability
Special features: Everything you need for a balanced life

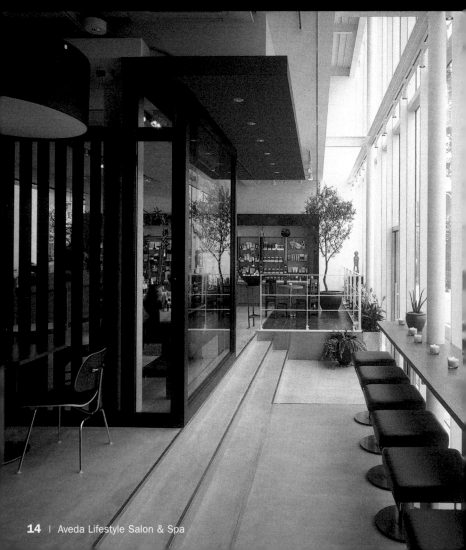

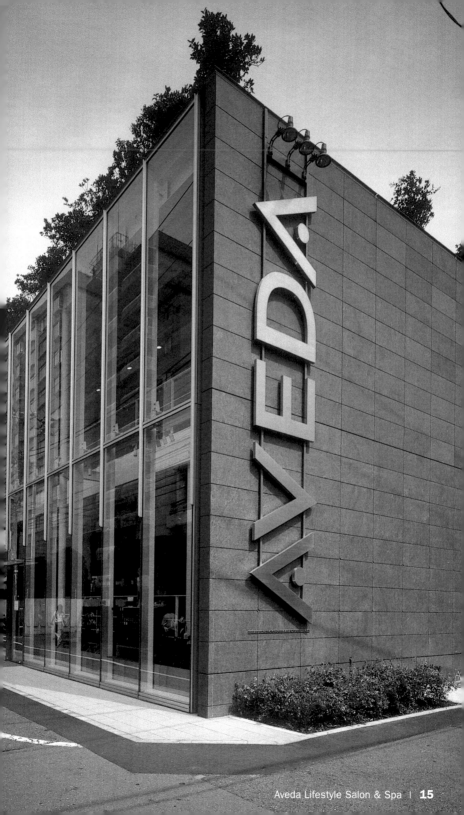

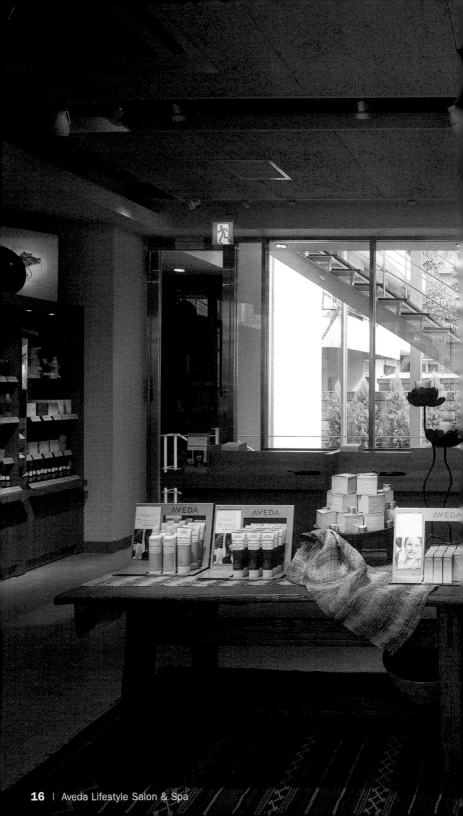

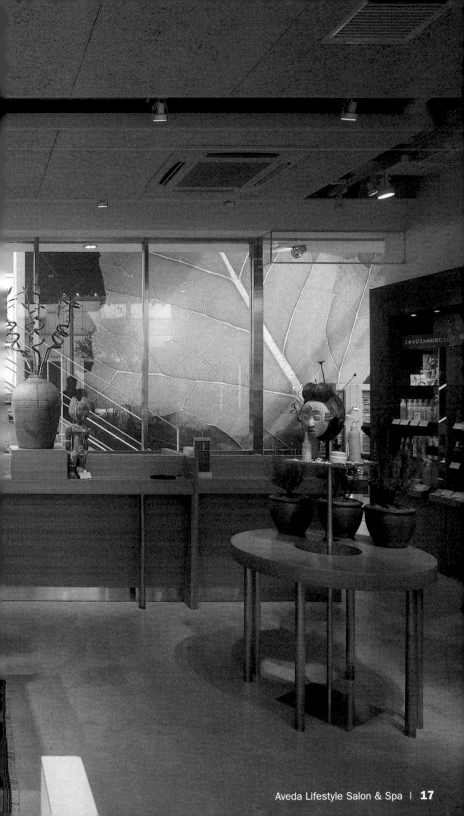

Beams House

Design: Hashimoto Yukio Design Studio

1F, Marunouchi Bldg., 2-4-1 Marunouchi | Tokyo 100-0000 | Chiyoda-ku
Phone: +81 3 5220 8686
www.beams.co.jp
Subway: Otemachi
Opening hours: Mon–Sun 11 am to 8 pm
Products: Clothes and accessories
Special features: Classic modern style

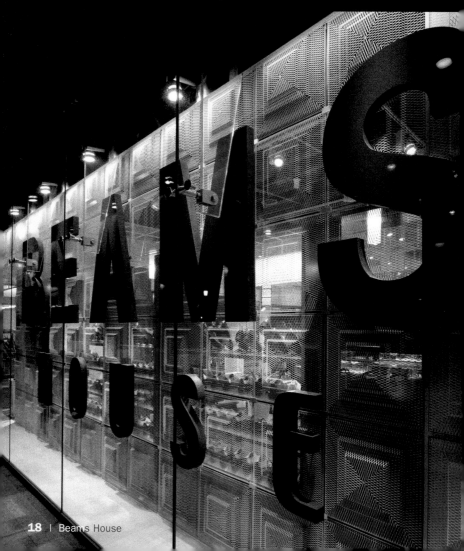

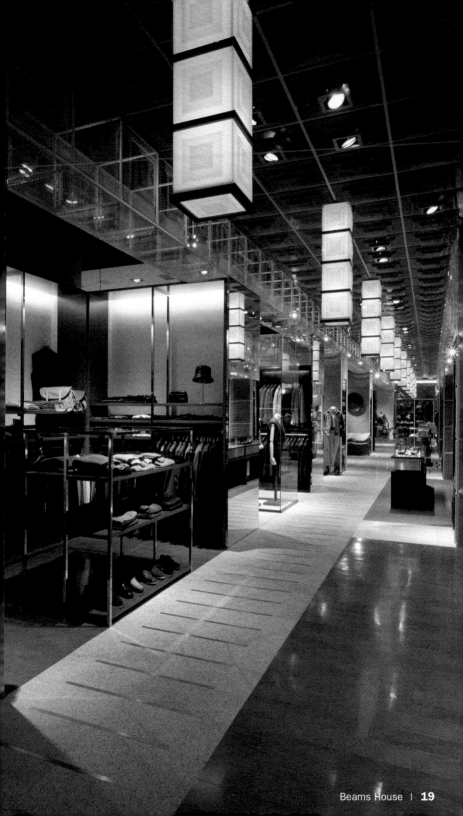

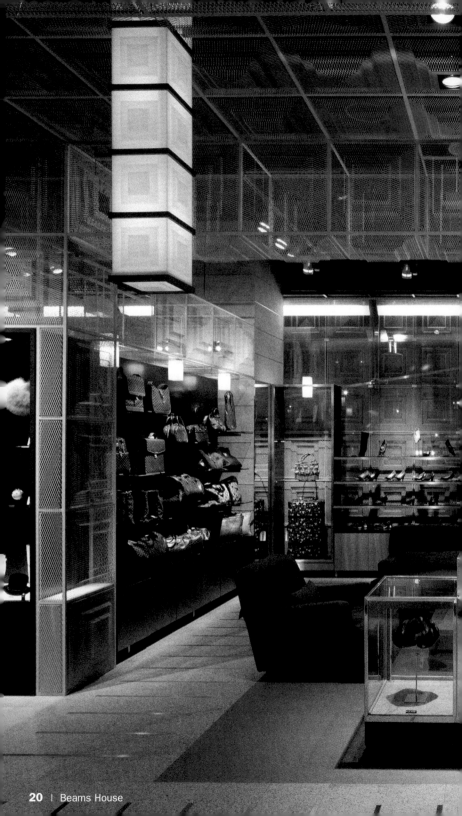

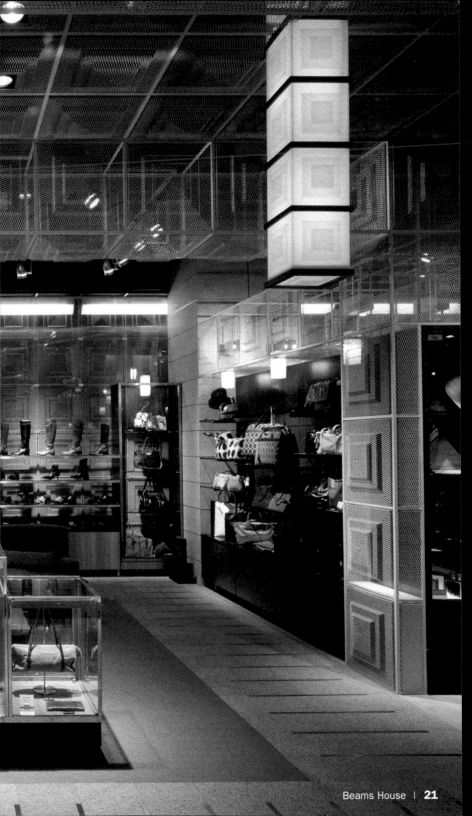

Beams Women
International Gallery

Design: Hashimoto Yukio Design Studio

3-25-15 Jingumae | Tokyo 150-0001 | Shibuya-ku
Phone: +81 3 3470 3925
www.beams.co.jp
Subway: Omotesando
Opening hours: Mon–Sun 11 am to 8 pm
Products: Beams basics plus a selection of rare accessories
Special features: A large space with everything from simple items to the most unusual accessory

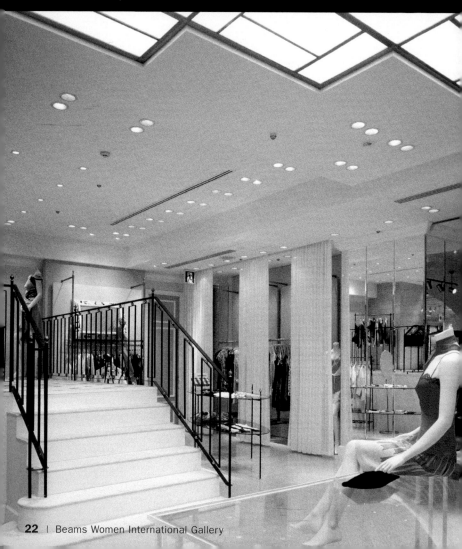

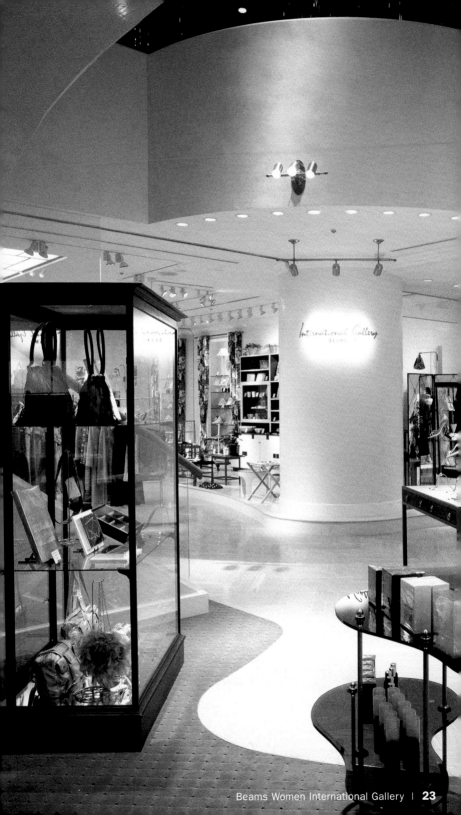

International Gallery
BEAMS

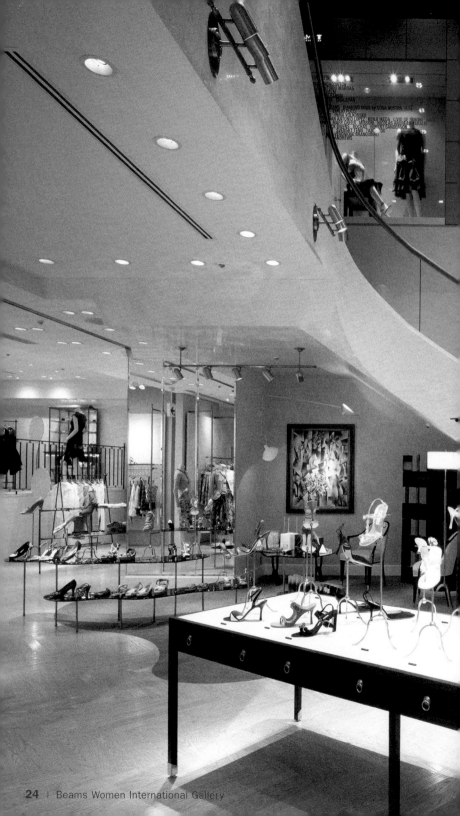

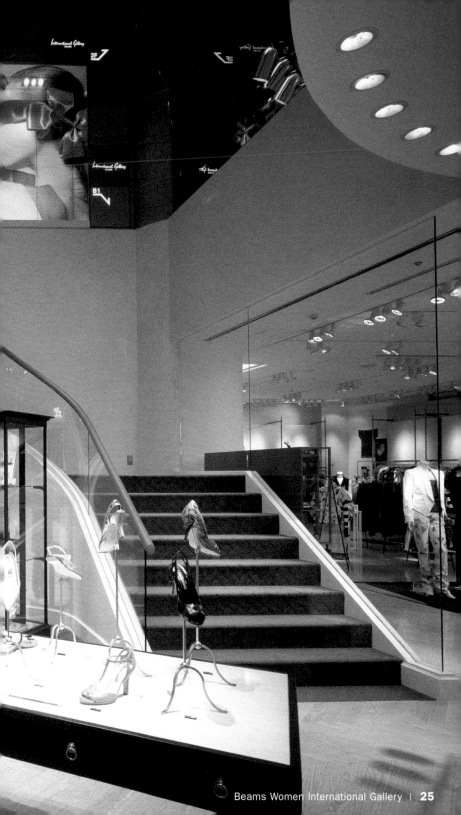

Christian Lacroix

Design: Christian Lacroix, CAPS Architects

24-4 Saraugaku-cho, Daikanyama | Tokyo 150-0033 | Shibuya-ku
Phone: +81 3 5784 3671
www.christian-lacroix.com
Subway: Daikanyama
Opening hours: Mon–Sun 11 am to 7 pm
Products: Clothes and accessories
Special features: The translucent colored walls produce different lighting effects
throughout the day

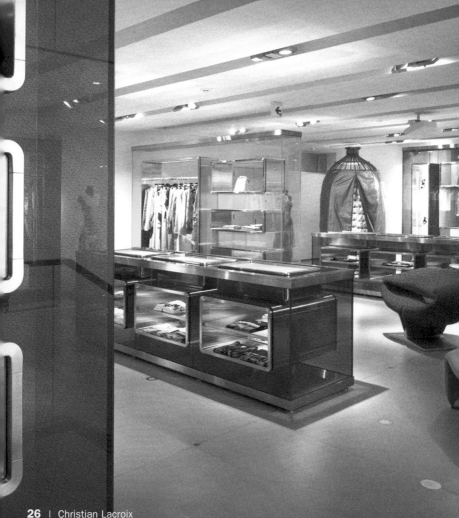

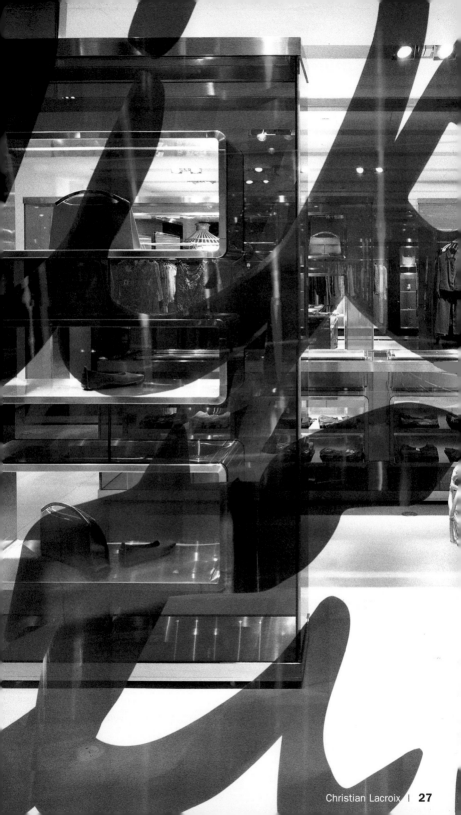

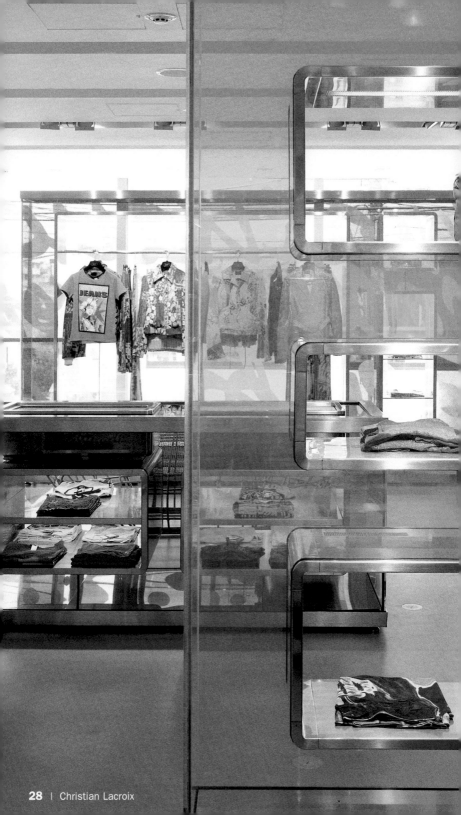

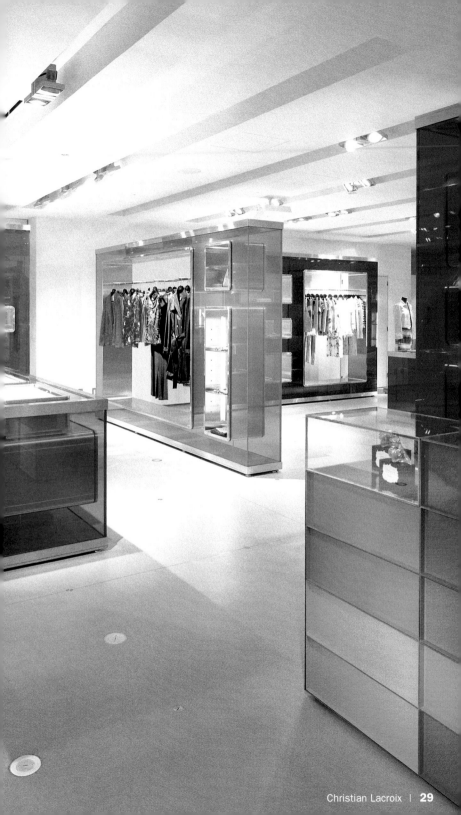

Citrus Notes

Design: Masaru Ito

2F, West Walk, Roppongi Hills I Tokyo 106-0032 I Minato-ku
Phone: +81 3 3796 8388
www.citrusnotes.com
Subway: Roppongi
Opening hours: Mon–Sun 11 am to 9 pm
Products: High-quality fashion
Special features: Contemporary classics for the urban woman

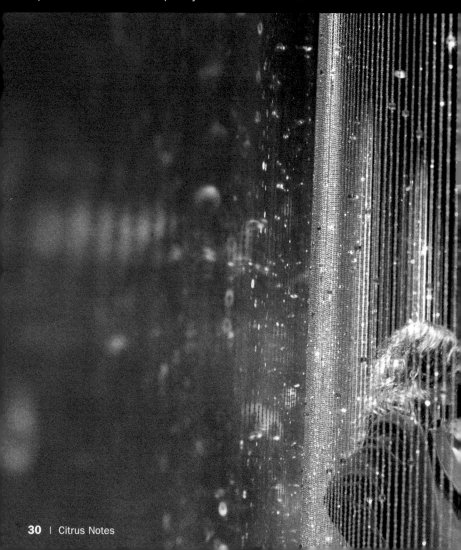

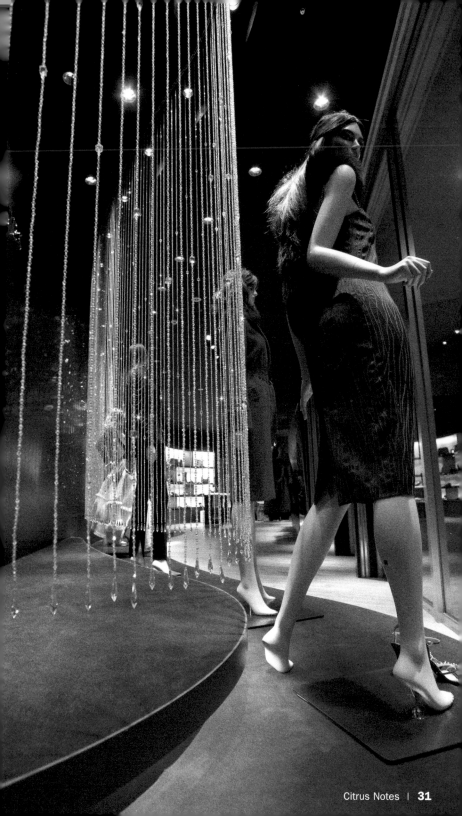

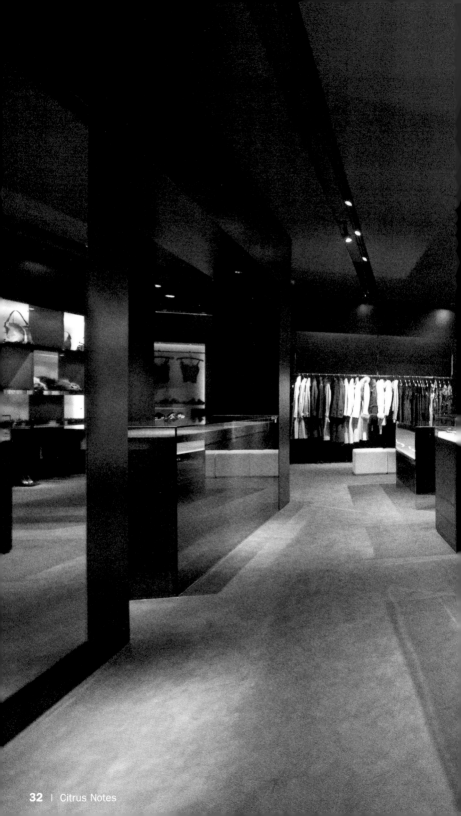

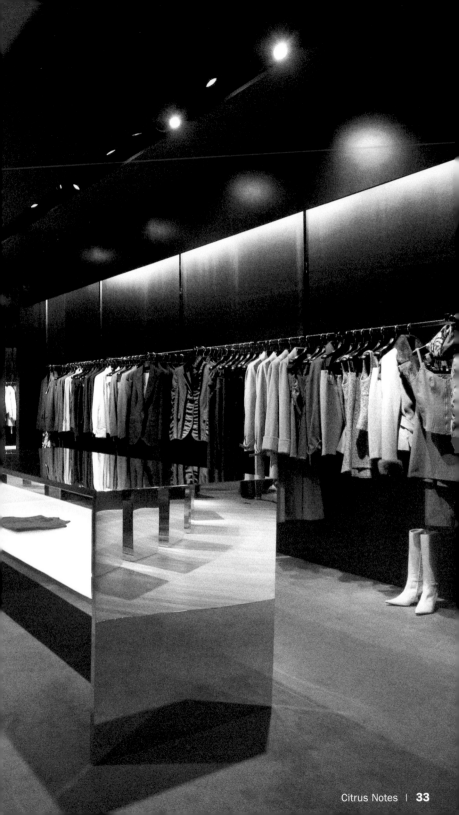

Custo Barcelona

Design: OUT.DeSIGN, Tsutomu Kurokawa

1-2 F, Aoyama Bldg., 3-2-2-Kita Aoyama I Tokyo 107-0061 I Minato-ku
Phone: +81 3 5414 5870
www.custo-barcelona.com
Subway: Aoyama Itchome
Opening hours: Mon–Sun 11 am to 7 pm
Products: Sophisticated casual wear
Special features: The undulating shop window generates an effect of transparence
and movement ideal for this young and fresh brand

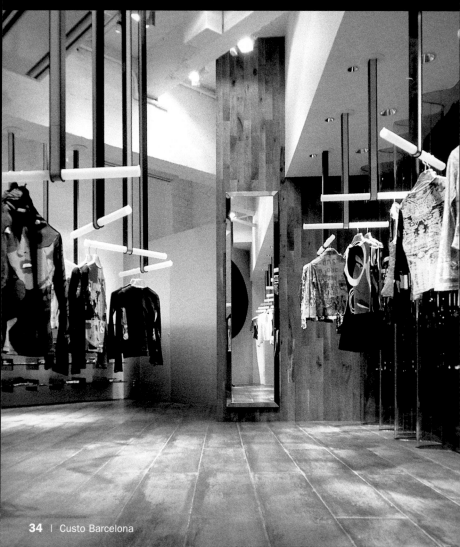

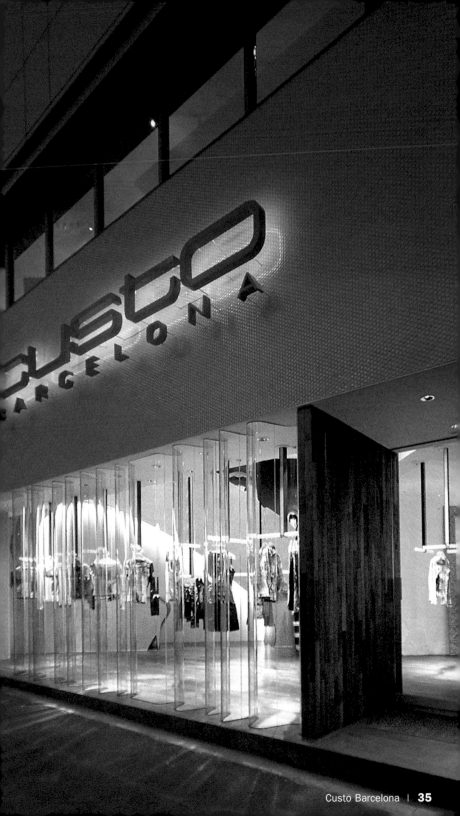

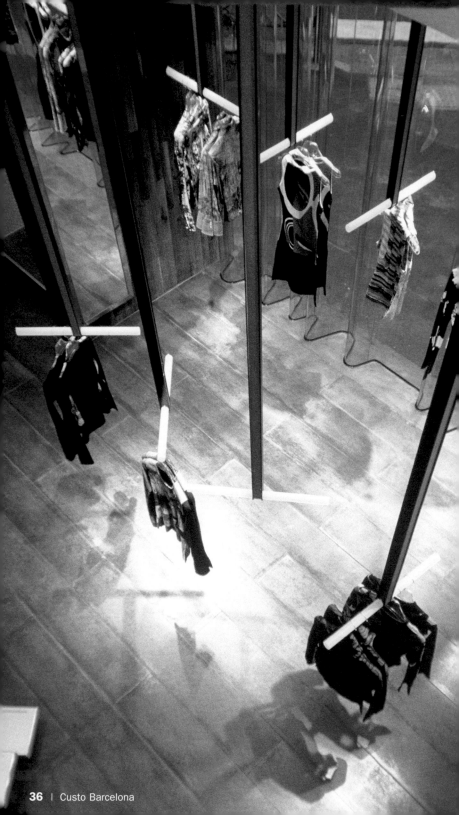

DazzliN' DazzlE

Design: Yosei Kiyono

1F, Tukahara Bldg., 6-10-12 Jingumae | Tokyo 150-0001 | Shibuya-ku
Phone: +81 3 5464 0446
www.dazzlindazzle.com
Subway: Meiji-jingumae
Opening hours: Mon–Sun 11 am to 9 pm
Products: Luxury casual

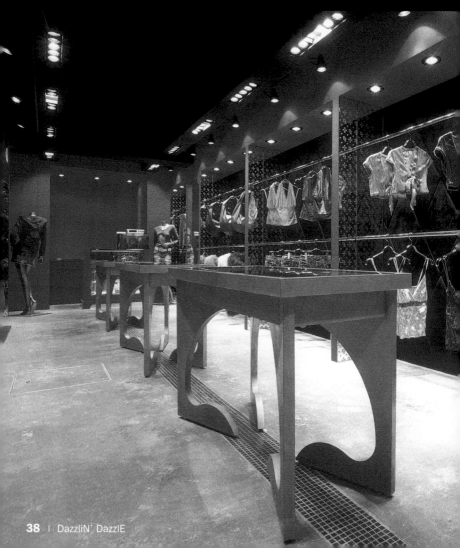

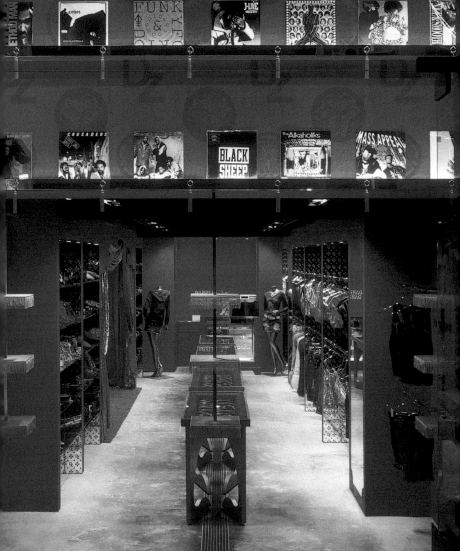

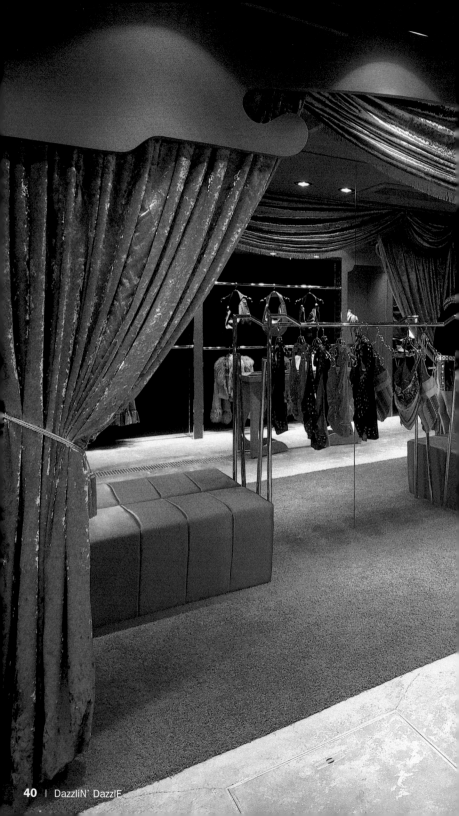

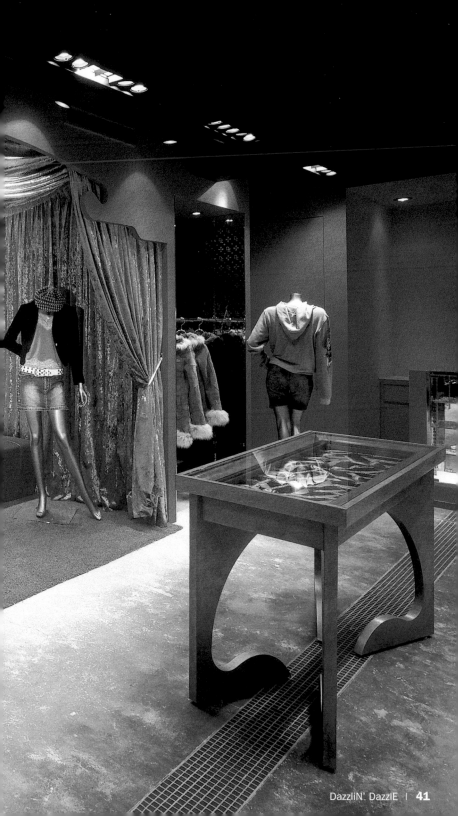

Dunhill

Design: Otani

Namiki-dori Boutique, 6-7-15 Ginza | Tokyo 104-0061 | Chuo-ku
Phone: +81 3 3289 0511
www.dunhill.com
Subway: Ginza
Opening hours: Mon–Sun 11 am to 7 pm
Products: Clothing and accessories for men
Special features: A refined cigarette brand translated into lifestyle

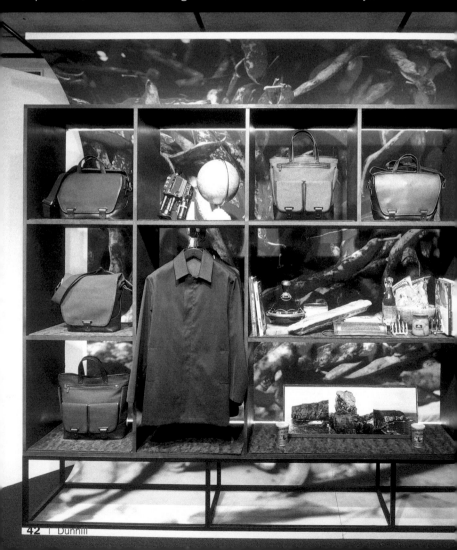

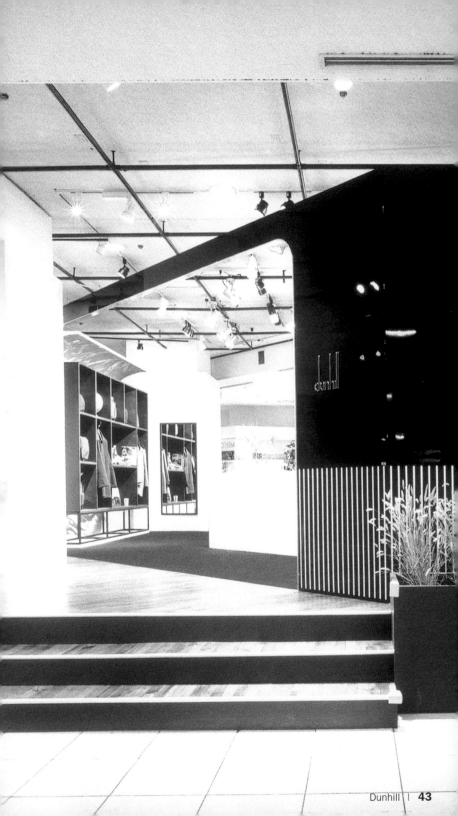

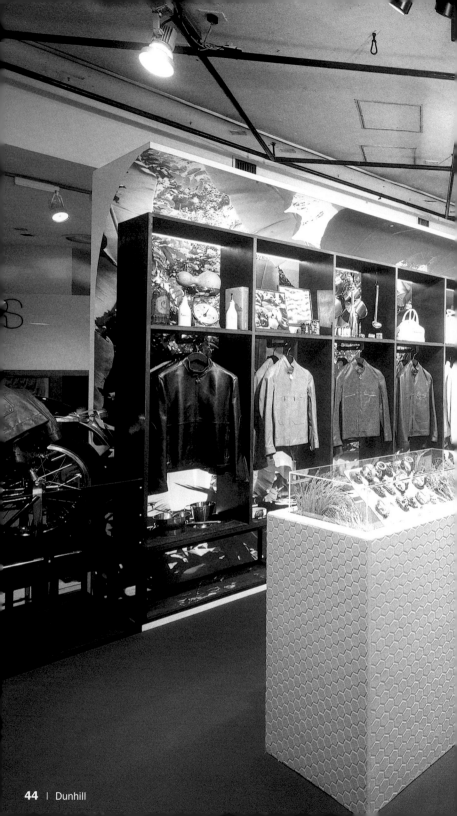

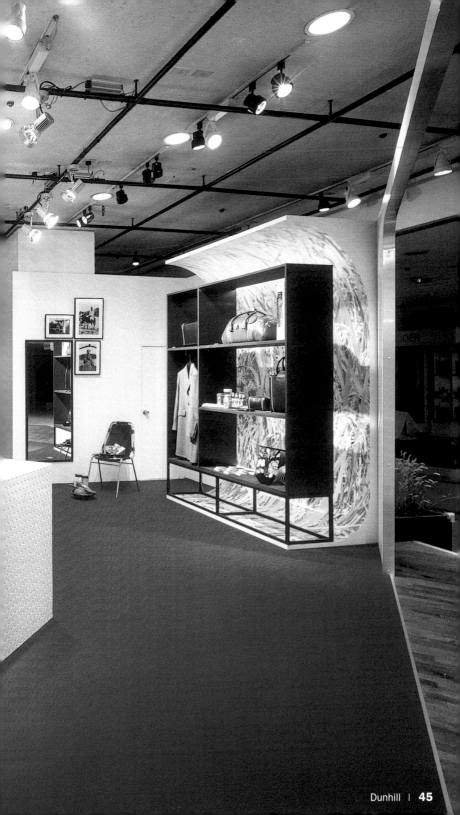

Gravis Footwear

Design: Otani

5F, Shinjuku Itesan, 3-14-1 Shinjuku I Tokyo 160-0022 I Shinjuku-ku
Phone: +81 3 3352 1111
www.gravisfootwear.com
Subway: Shinjuku
Opening hours: Mon–Sun 10 am to 8 pm
Products: Footwear, clothes and bags for surfers and snowboarders
Special features: Surfing atmosphere in the heart of the city

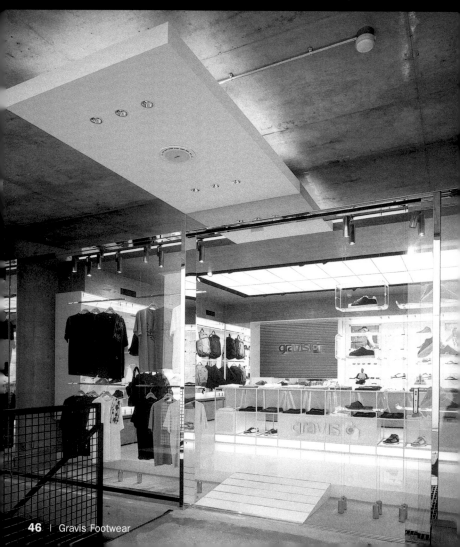

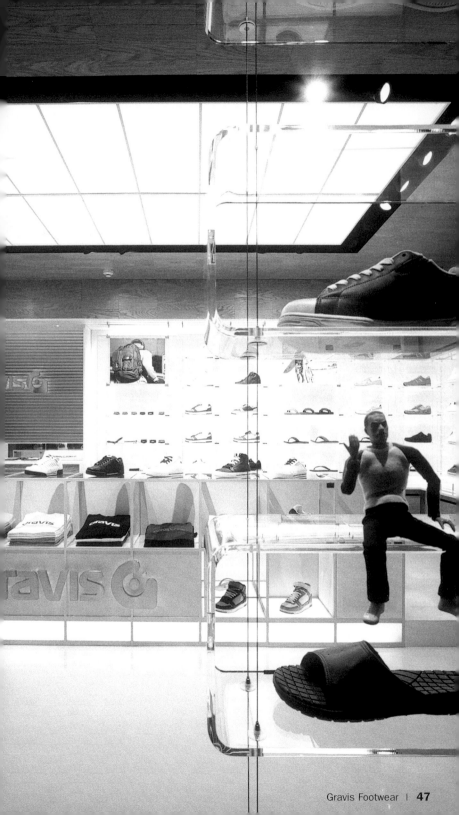

HHstyle

Design: Tadao Ando

6-14-5 Jingumae | Tokyo 151-0001 | Shibuya-ku
Phone: +81 3 3400 3434
www.hhstyle.com
Subway: Meiji-jingumae, Omotesando
Opening hours: Mon–Sun noon to 8 pm
Products: The most prestigious clothing brands

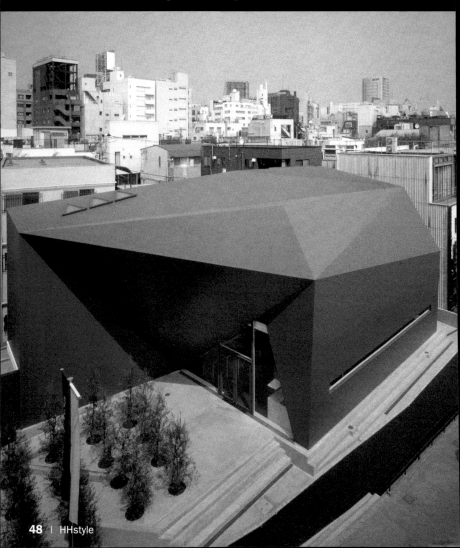

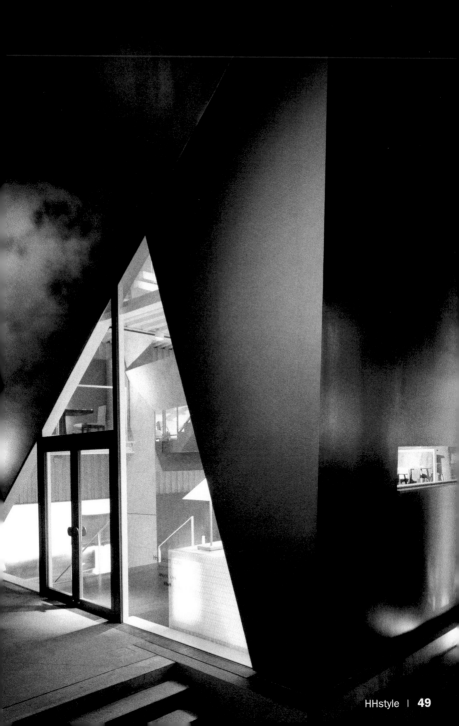

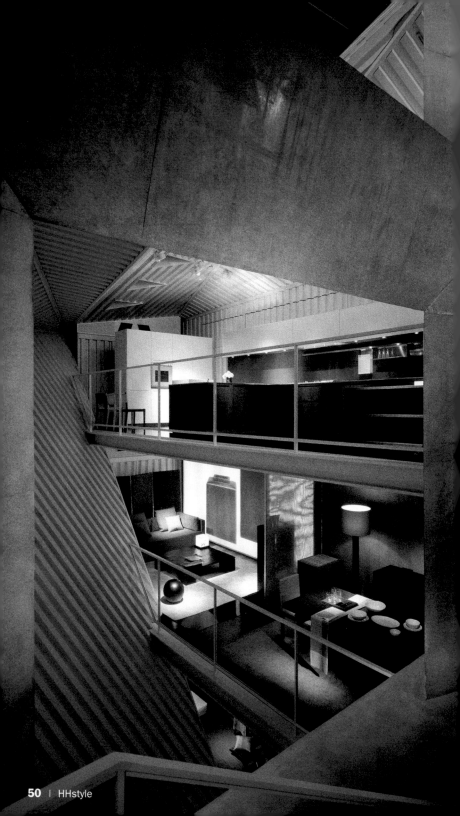

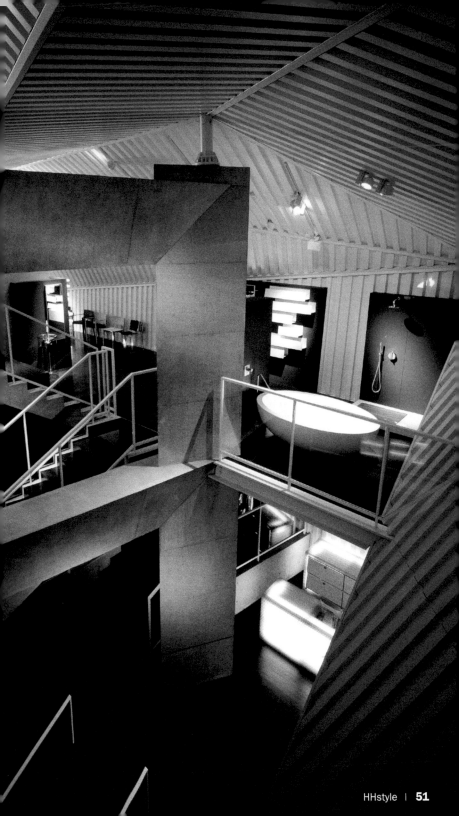

Lanvin

Design: Takushi Nakamura

7-9-17 Ginza | Tokyo 104-0061 | Chuo-ku
Phone: +81 3 3289 2788
www.lanvin.com
Subway: Ginza
Opening hours: Mon–Fri 11:30 am to 8 pm, Sat–Sun 11:30 am to 7:30 pm
Products: Men's and women's luxury fashion
Special features: The perforated wall in the entrance herald the meticulous
interior design, which is totally urban in style

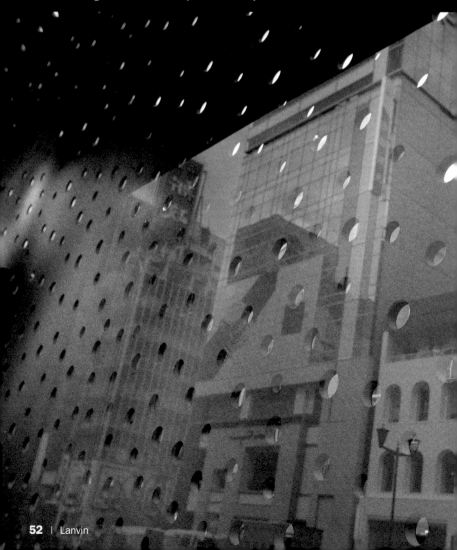

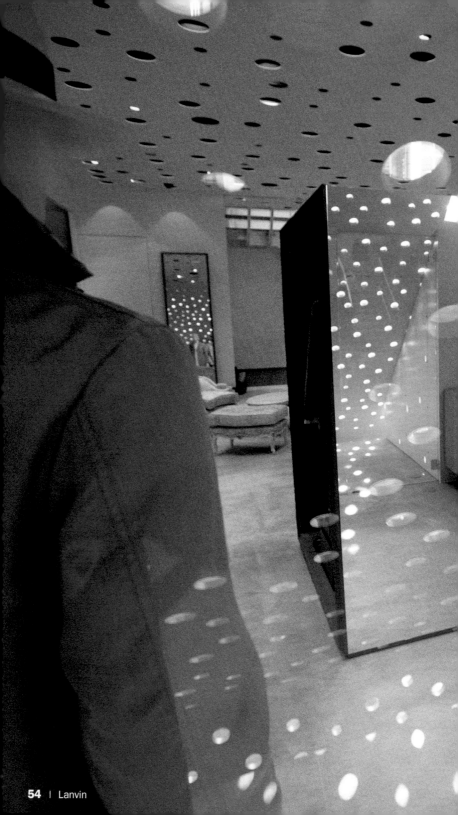

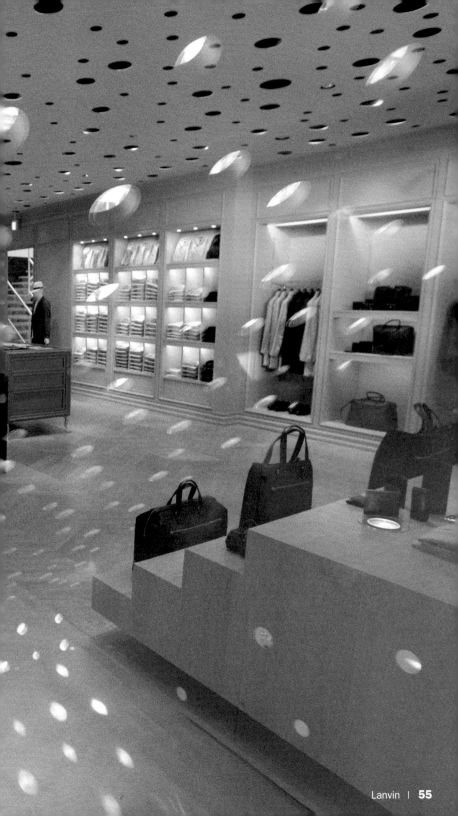

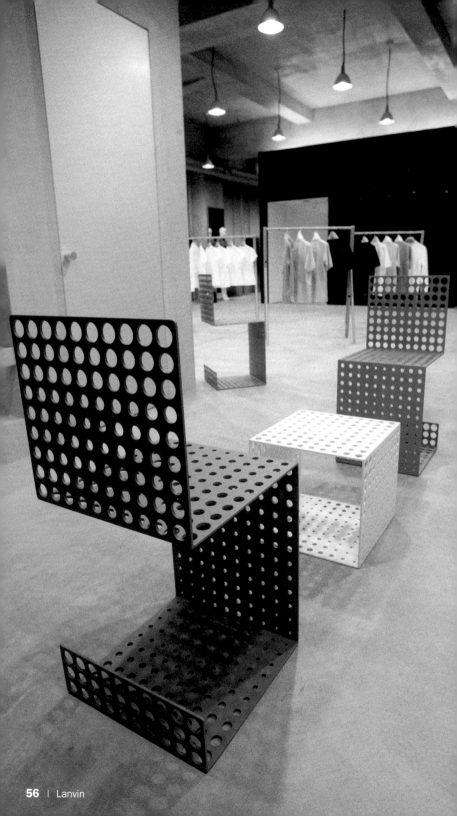

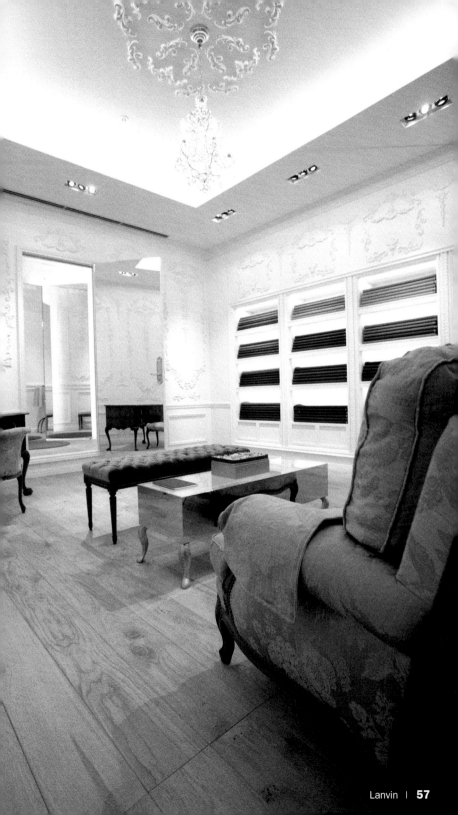

Loree Rodkin

Design: Loree Rodkin, Tetsuro Seki

1F/B1F, Ginza-Sakurai Bldg., 1-6-15 Ginza | Tokyo 104-0061 | Chuo-ku
Phone: +81 3 3538 0330
www.loreerodkin.com
Subway: Ginza
Opening hours: Mon–Sun 11 am to 8 pm
Products: Jewelry
Special features: Dramatic jewelry with Gothic design

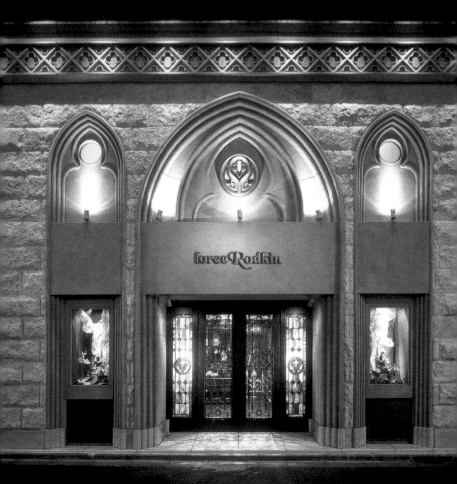

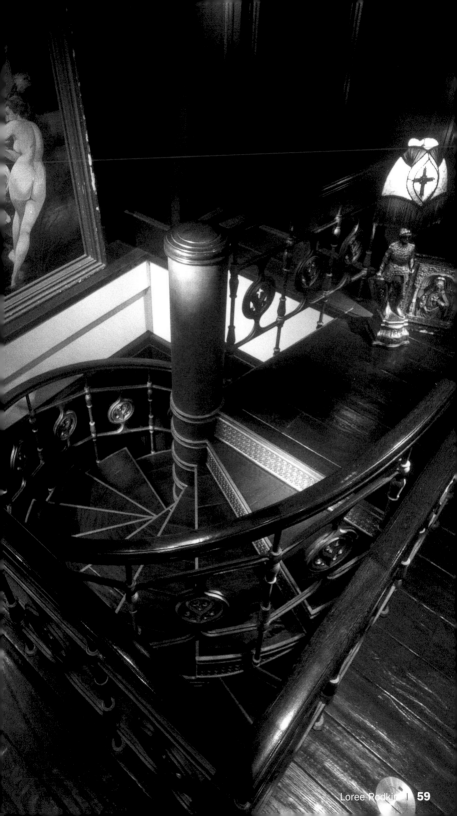

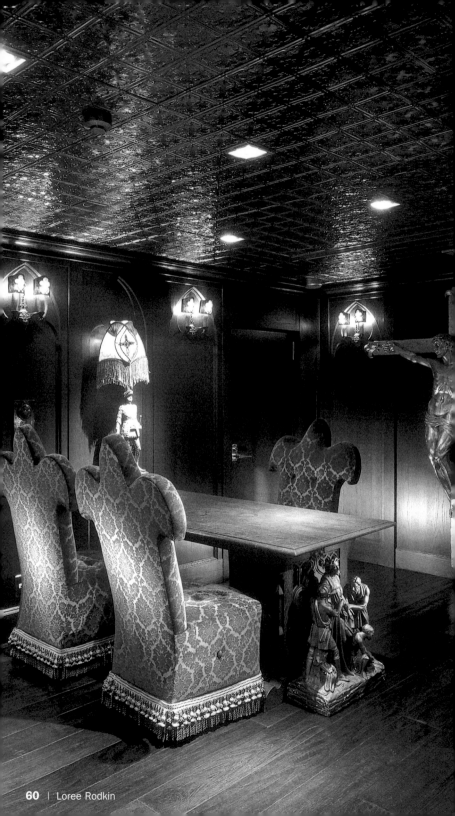

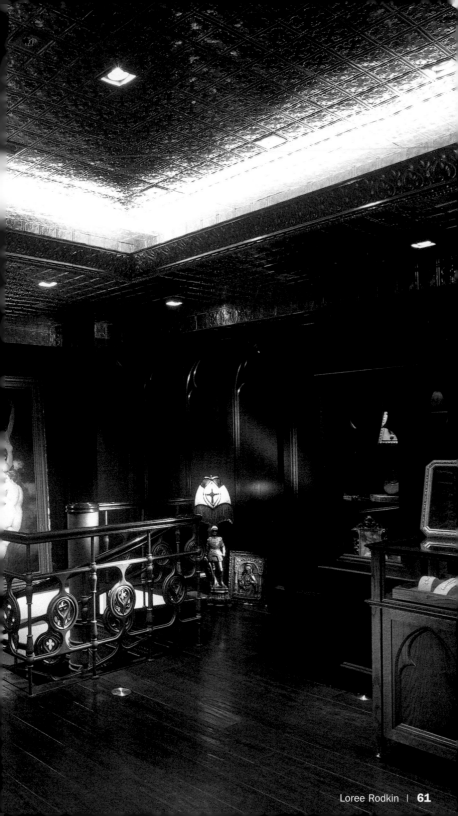

M-Premier Black

Design: Fumita Design Office

3F, Takashimaya Tokyo Store, 2-4-1 Nihonbashi I Tokyo 103-0027 I Chuo-ku
Phone: +81 3 3241 2800
www.m-premier.jp
Subway: Nihombashi
Opening hours: Mon–Sun 11 am to 7 pm
Products: Minimalist design apparel
Special features: Elegant design and quality materials characterize this refined f

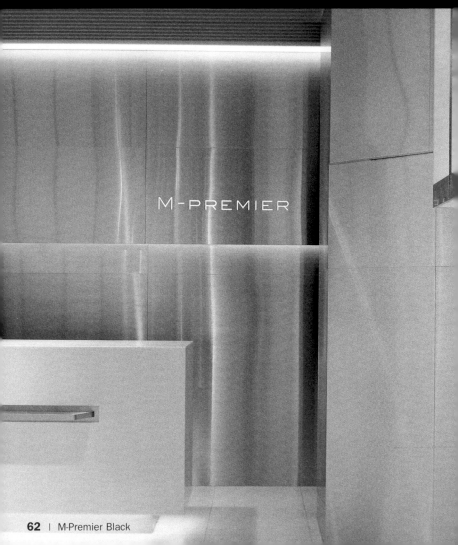

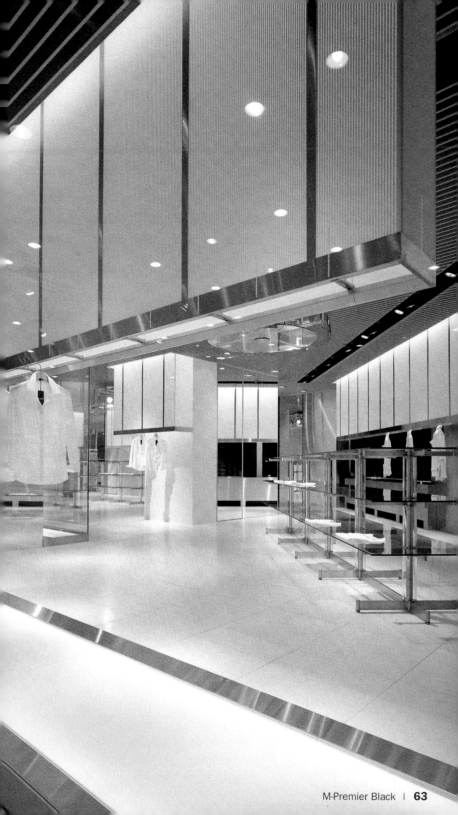

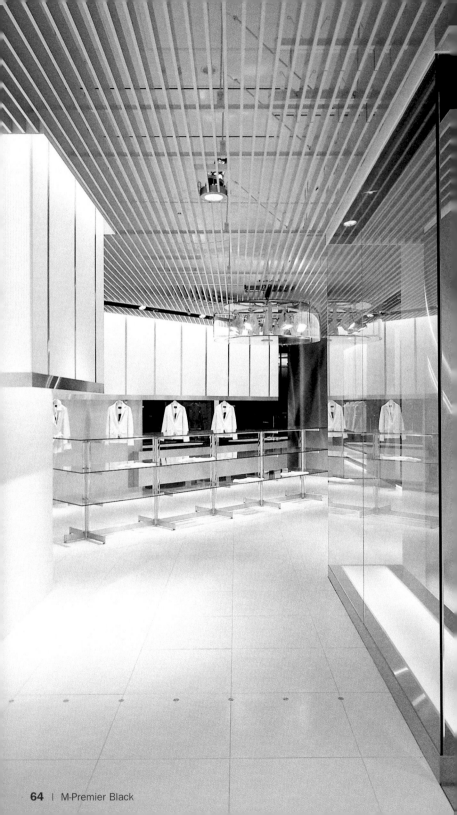

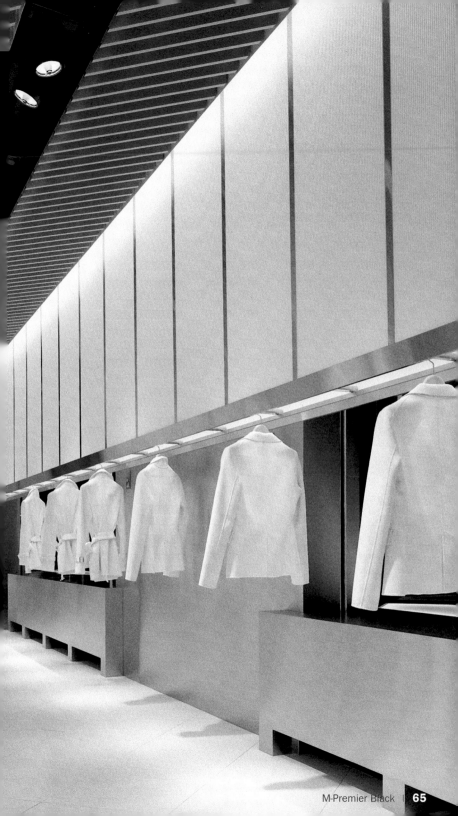

Miss Sixty

Design: Koji Sakai

1F, Jingumae Media Square Bldg., 6-25-14 Jingumae | Tokyo 150-0001 | Shibu
Phone: +81 3 5464 1426
www.misssixty.com
Subway: Omotesando
Opening hours: Mon–Sun 10:30 am to 8 pm
Products: Men's and women's casual street wear
Special features: The decoration with pop influences establishes three differen
settings

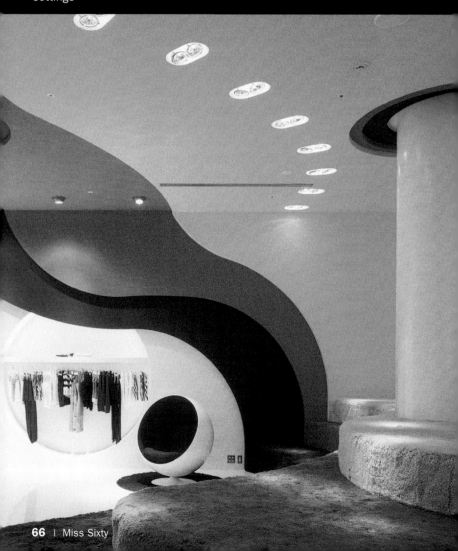

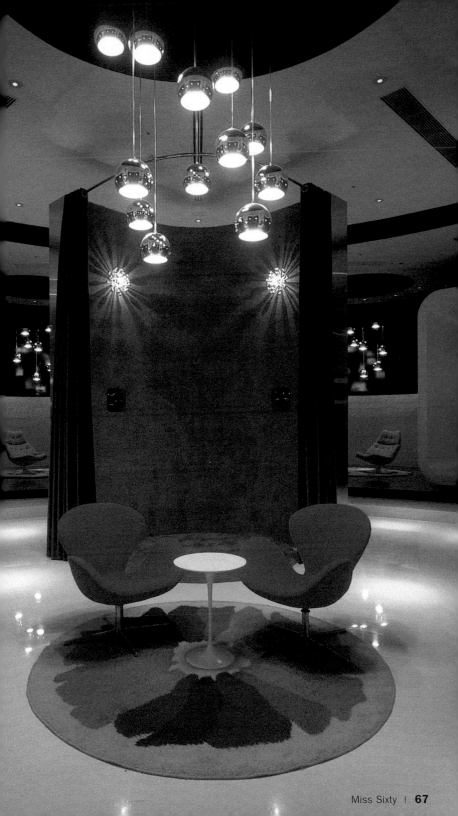

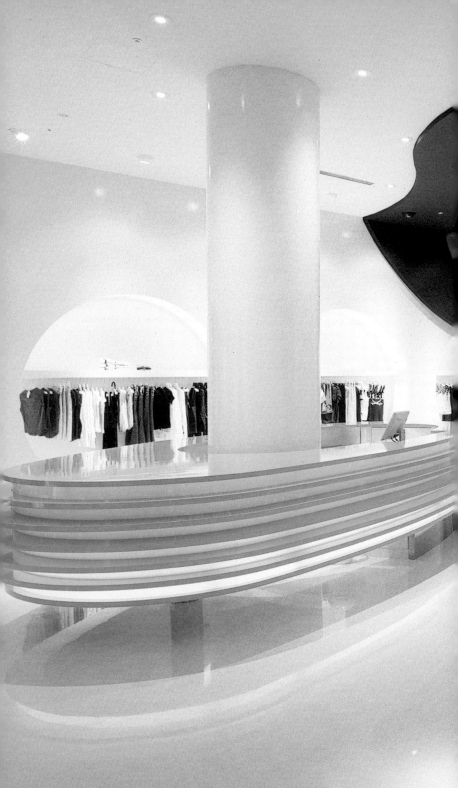

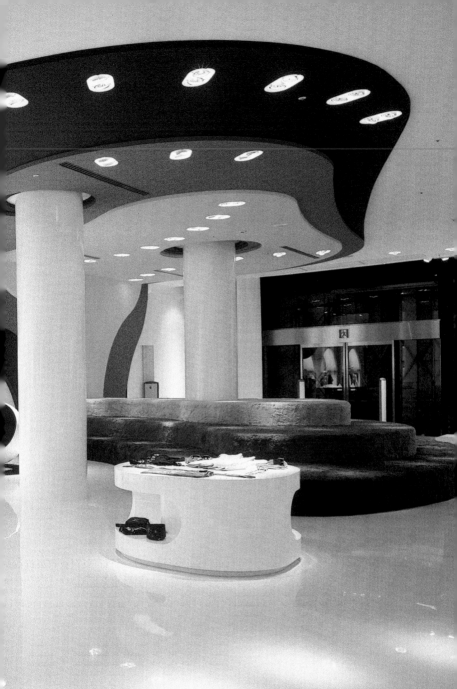

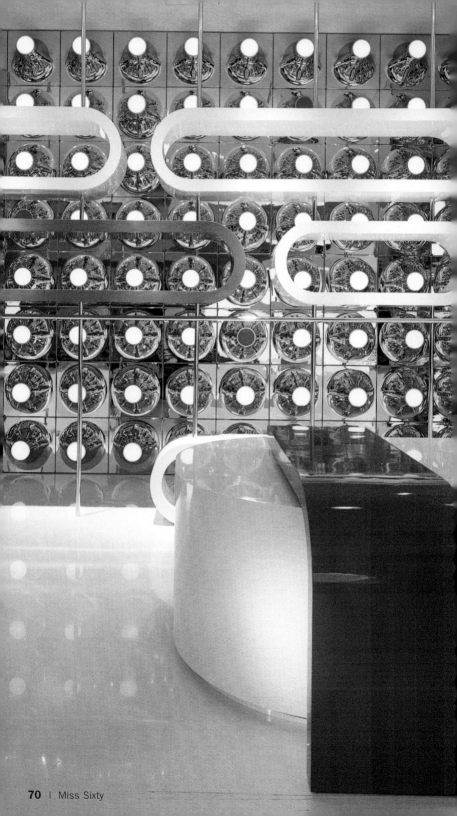

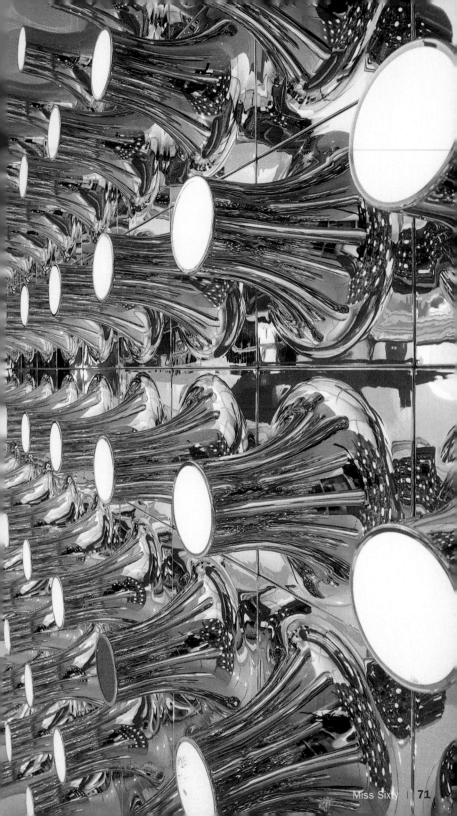

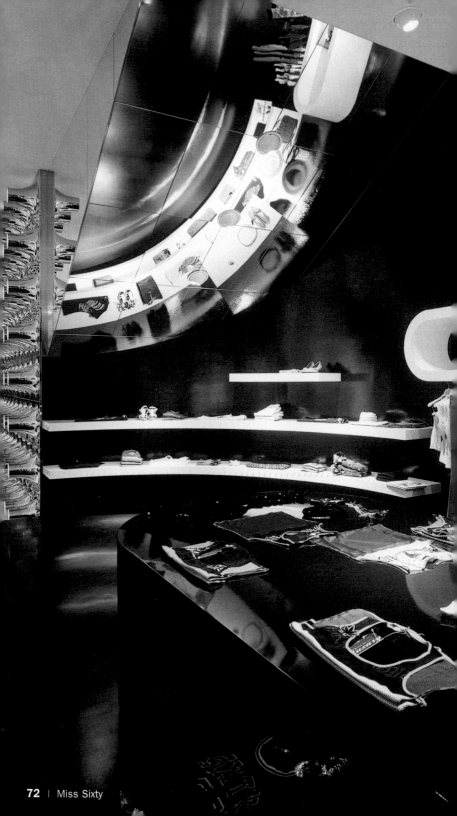

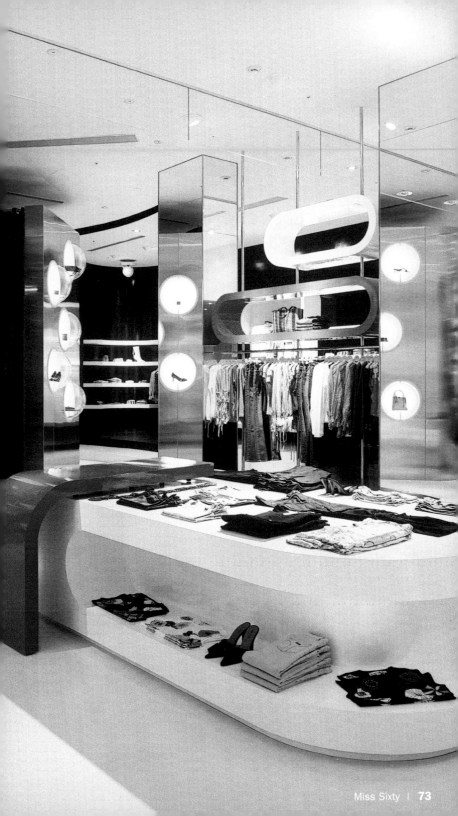

Nissan Gallery

Design: Fumita Design Office

Sapporo Ginza Bldg., 5-8-1 Ginza | Tokyo 104-0061 | Chuo-ku
Phone: +81 3 3572 4778
www.nissan-global.com
Subway: Ginza
Opening hours: Mon–Sun 10 am to 8 pm
Products: Luxury Nissan cars
Special features: High-tech atmosphere

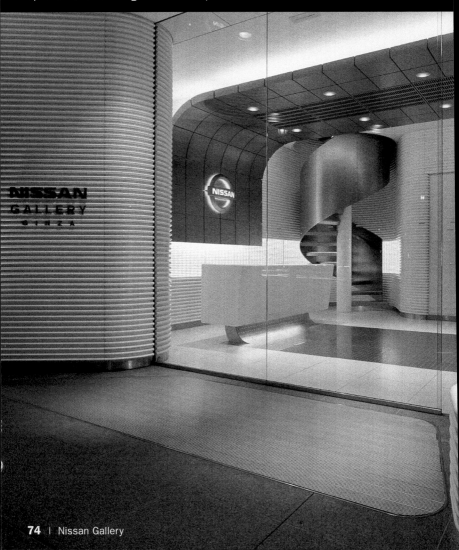

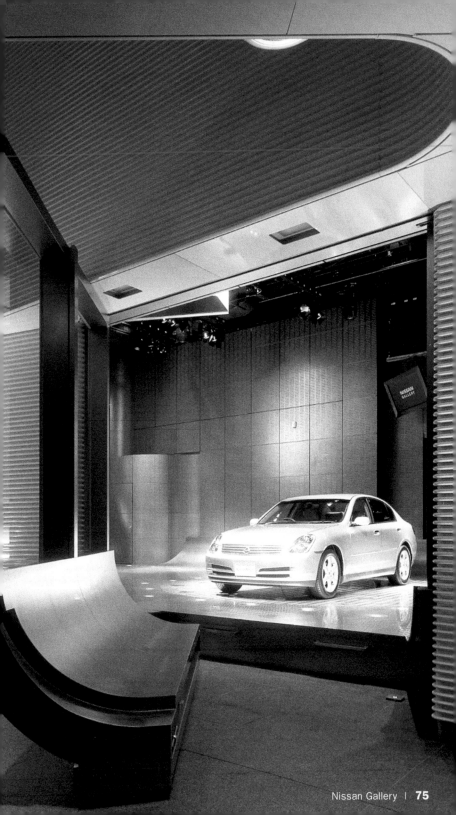

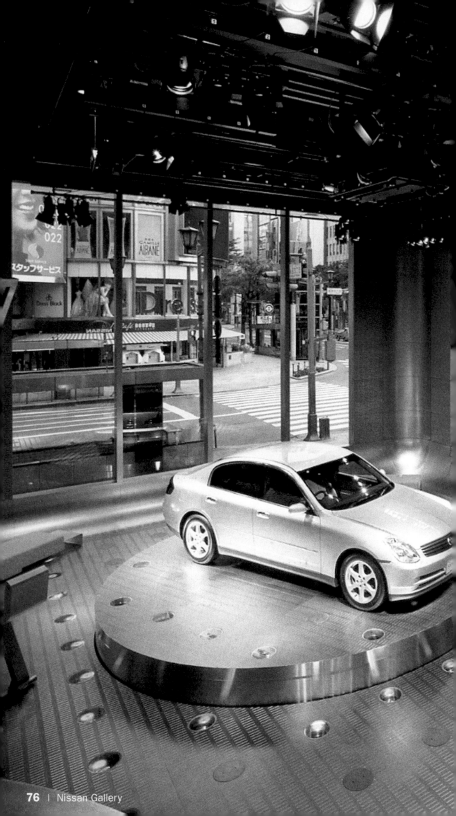

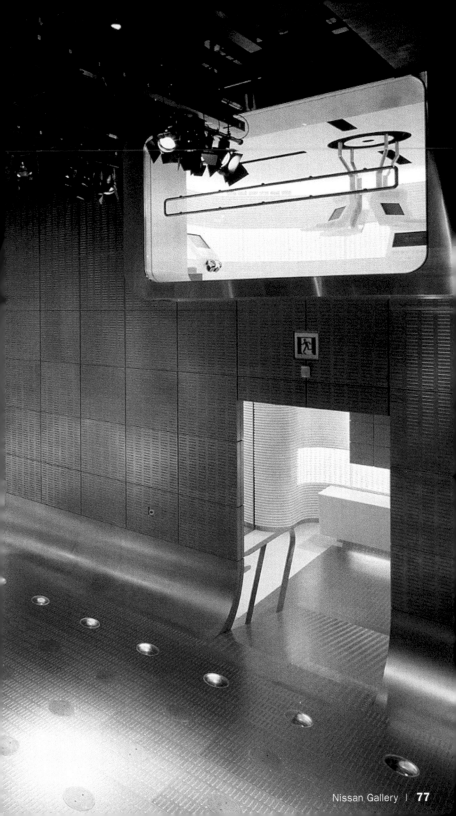

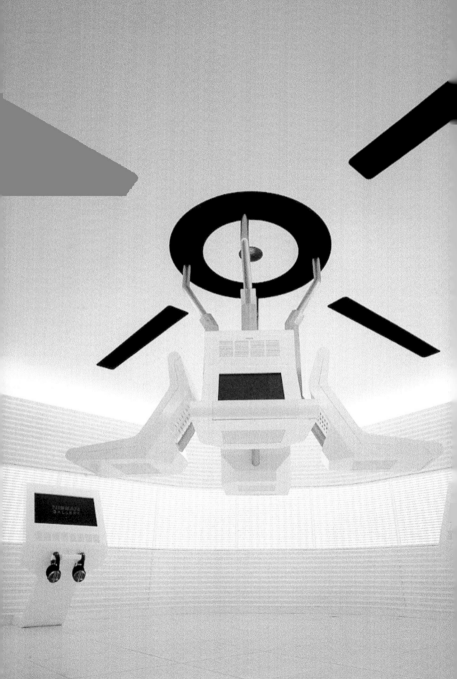

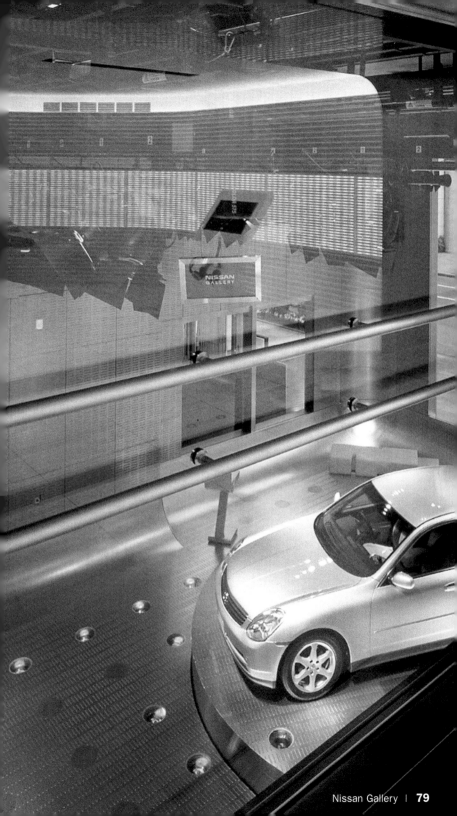

Obj.east

Design: Kenichi Otani

2-8-9 Ginza | Tokyo 104-0061 | Chuo-ku
Phone: +81 3 3538 3456
www.obj.co.jp
Subway: Ginza
Opening hours: Mon–Sun 11 am to 8 pm
Products: Glasses
Special features: The store window merges with the interior, where the design is
inspired by the form of a bridge

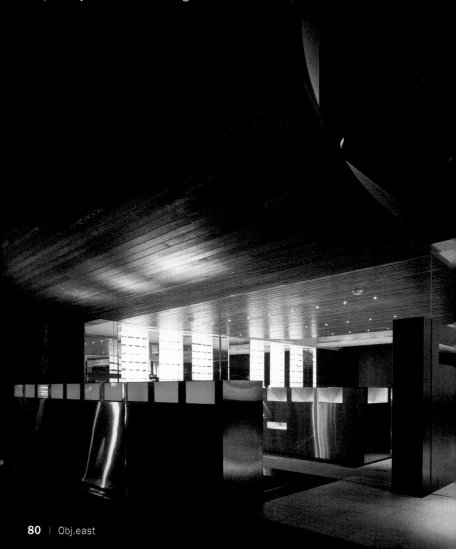

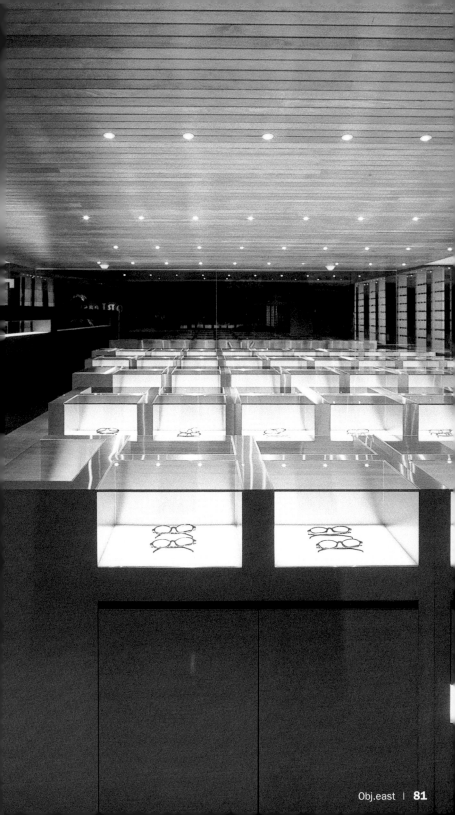

Pierre Hermé

Design: Wonderwall, Masamichi Katayama

1F & 2F, La Porte Aoyama, 5-51-8 Jingumae | Tokyo 150-0001 | Shibuya-ku
Phone: +81 3 5485 7766
www.pierreherme.com
Subway: Omotesando
Opening hours: Mon–Sun 11 am to 7 pm
Products: Haute pâtisserie
Special features: One of Paris' best designer pâtisseries in the Japanese capita

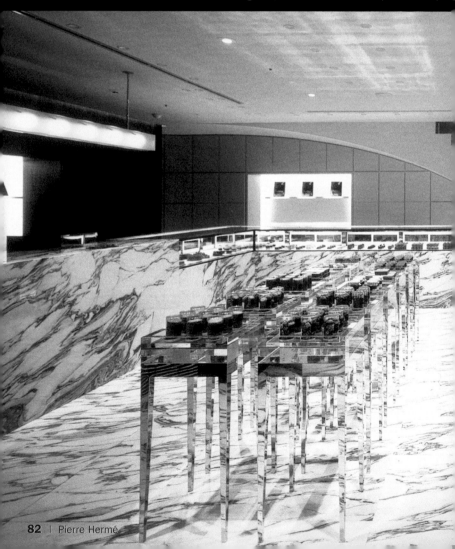

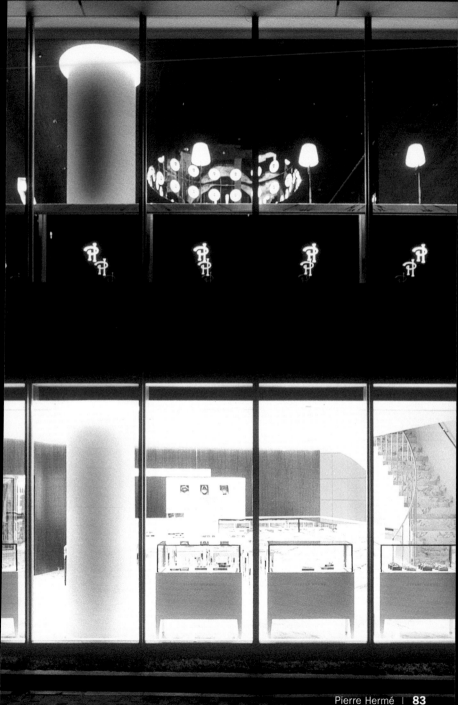

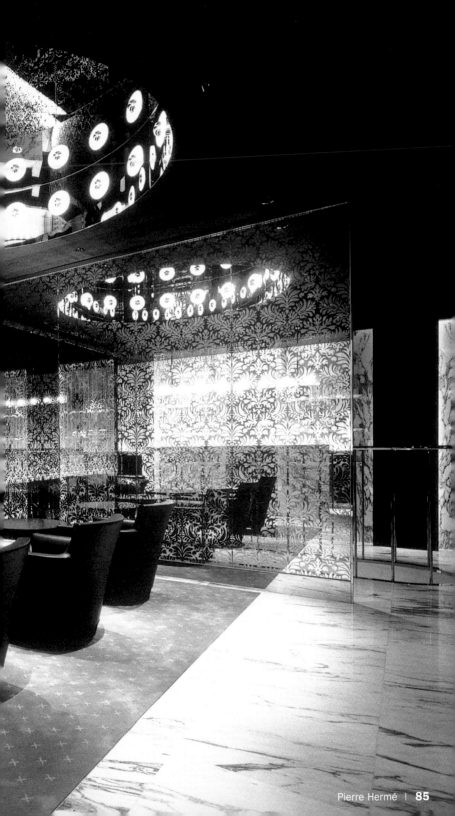

Prada
Aoyama Boutique

Design: Herzog & de Meuron

5-2-6 Minami-Aoyama I Tokyo 107-0062 I Minato-ku
Phone: +81 3 6418 0400
Subway: Omotesando
Opening hours: Mon–Sun 11 am to 8 pm
Products: Clothes and accessories
Special features: The spectacular Herzog & de Meuron building is an incompara
framework for the most sought-after brand in the city

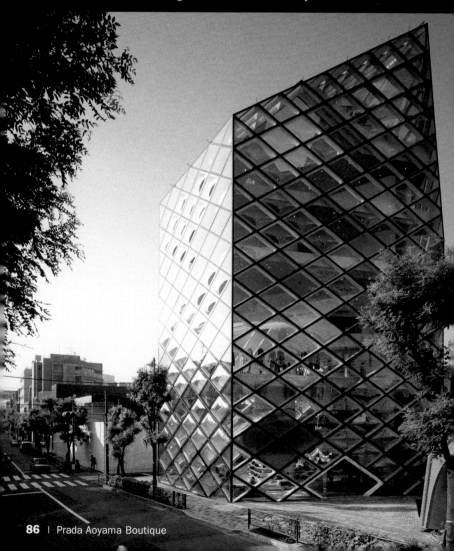

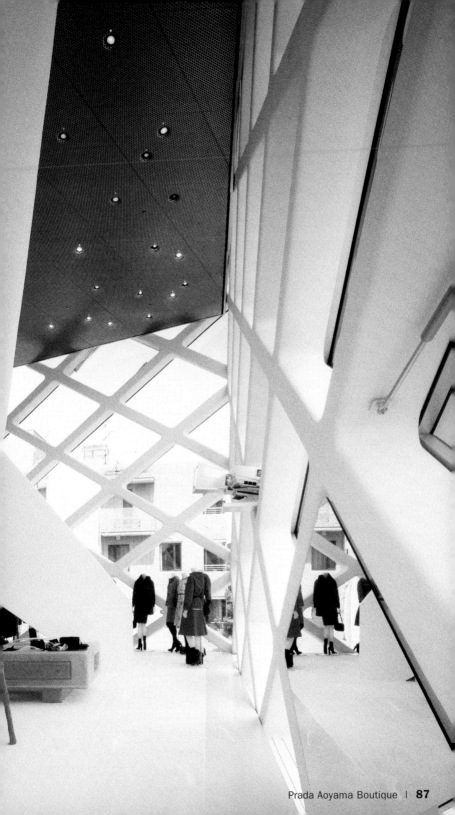

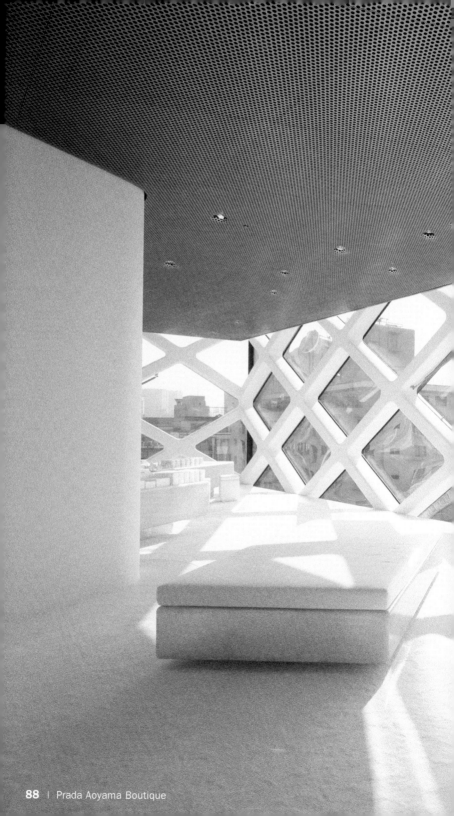

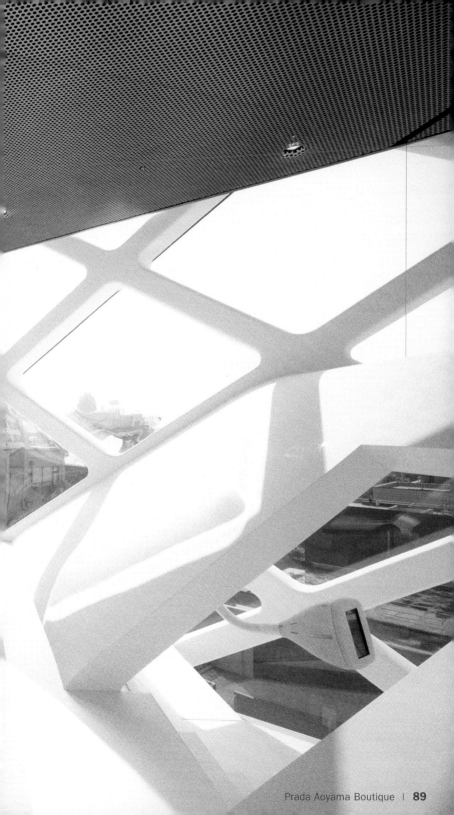

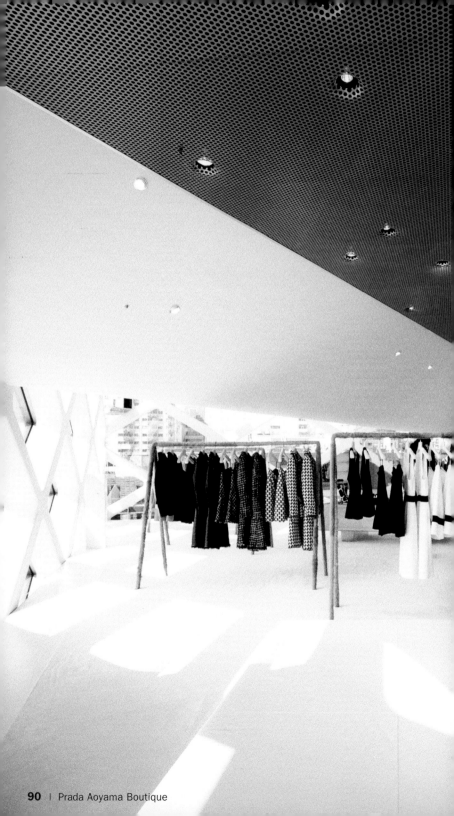

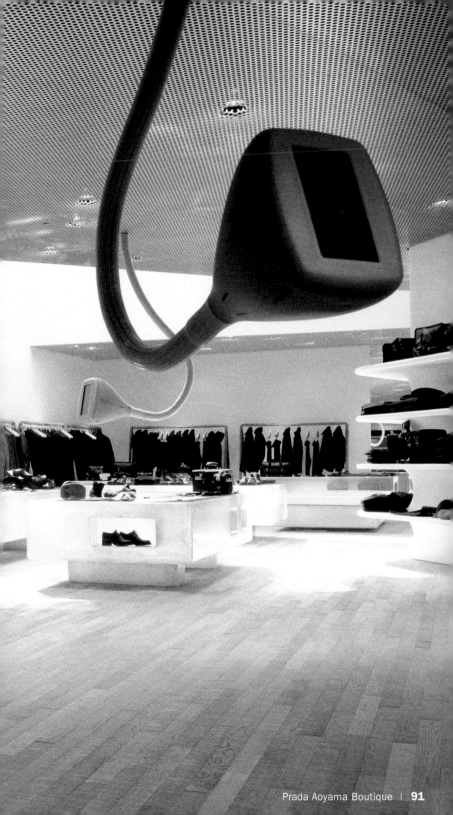

Pinceau

Design: OUT.DeSIGN, Tsutomu Kurokawa

2-4-1 Marunochi I Tokyo 100-6302 I Chida-ku
Phone: +81 3 5220 7568
www.adametrope.com/pinceau
Subway: Tokyo Station
Opening hours: Mon–Sun 11 am to 7 pm
Products: Basic apparel
Special features: The design affords space and clarity to this young and sporty collection

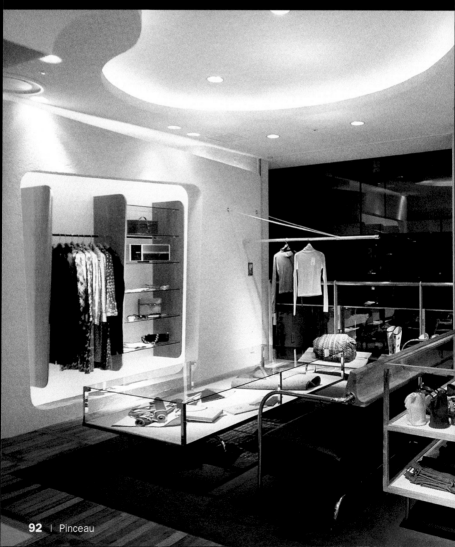

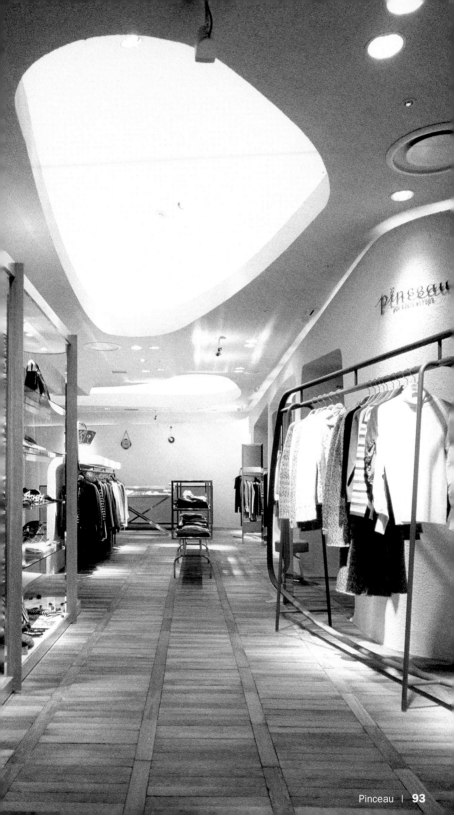

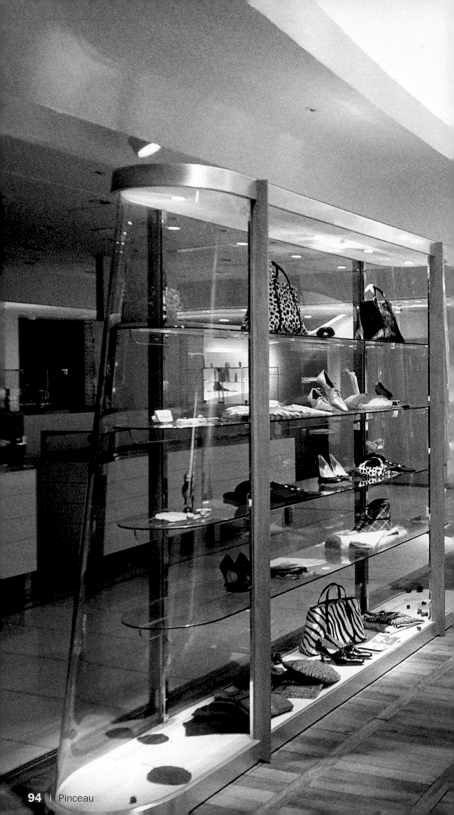

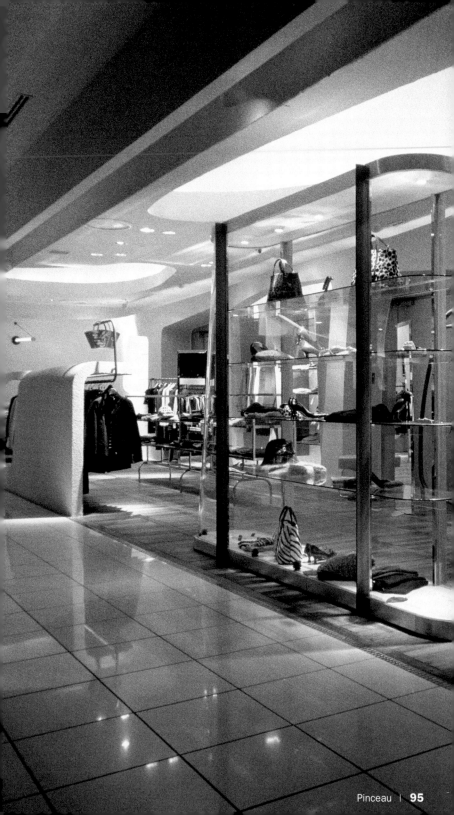

Rodenstock

Design: Shuhei Endo

2-1 Chome Shiba Daimon | Tokyo 105-0012 | Minato-ku
Phone: +81 3 6274 5111
www.rodenstock.com
Subway: Daimon
Opening hours: Mon–Sun 10 am to 7 pm
Products: Glasses
Special features: The look of a golf course in a confined space

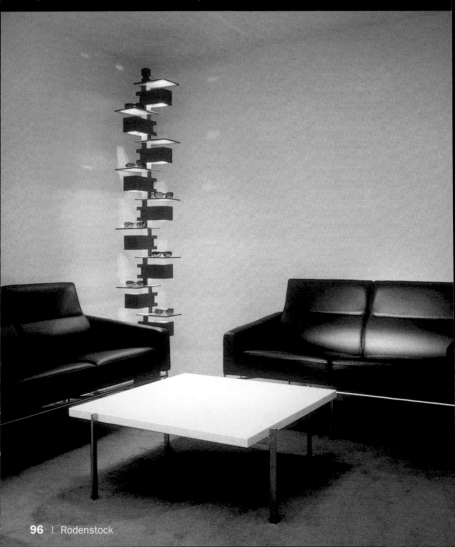

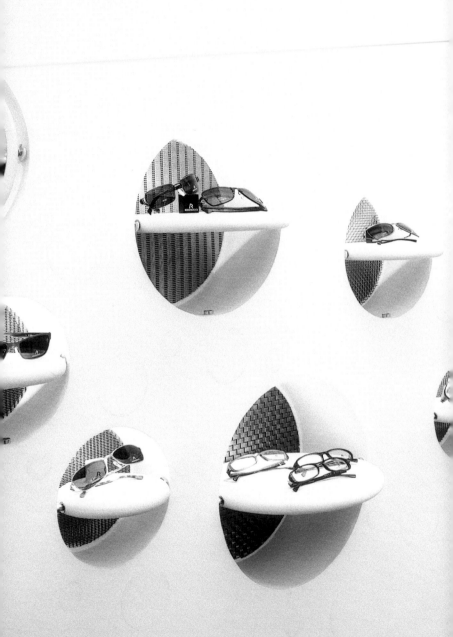

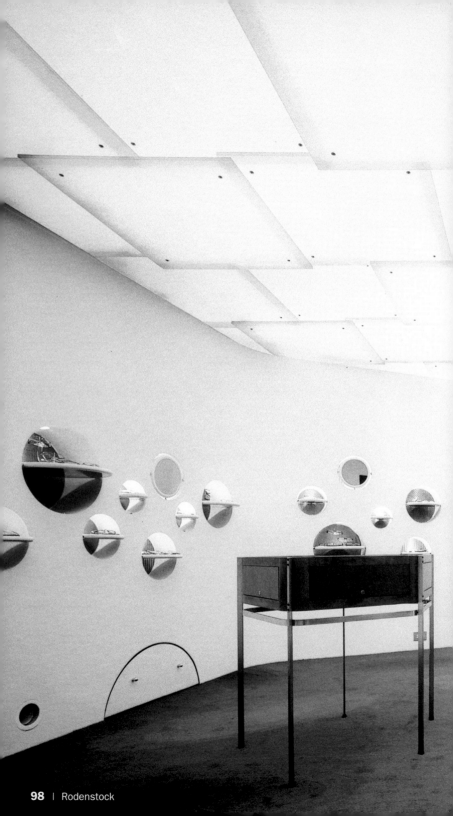

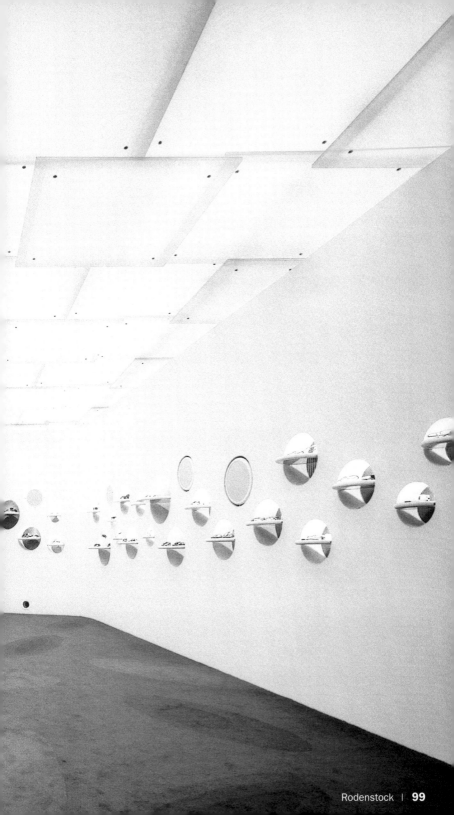

Samantha Thavasa

Design: Glamourous

2F, Aoyama Bldg., 1-2-3 Kitaaoyama I Tokyo 107-0061 I Minato-ku
Phone: +81 3 5774 0666
www.samantha.co.jp
Subway: Omotesando
Opening hours: Mon–Sun 11 am to 8 pm
Products: Bags, accessory and jewelry production

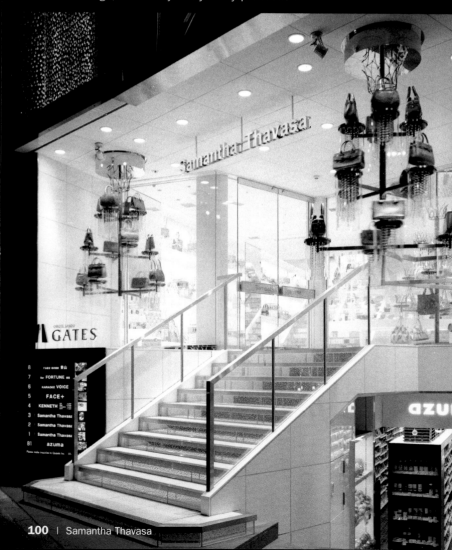

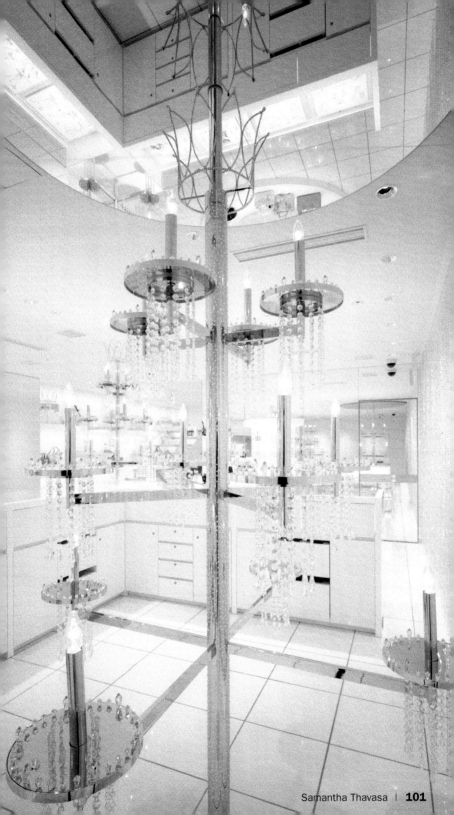

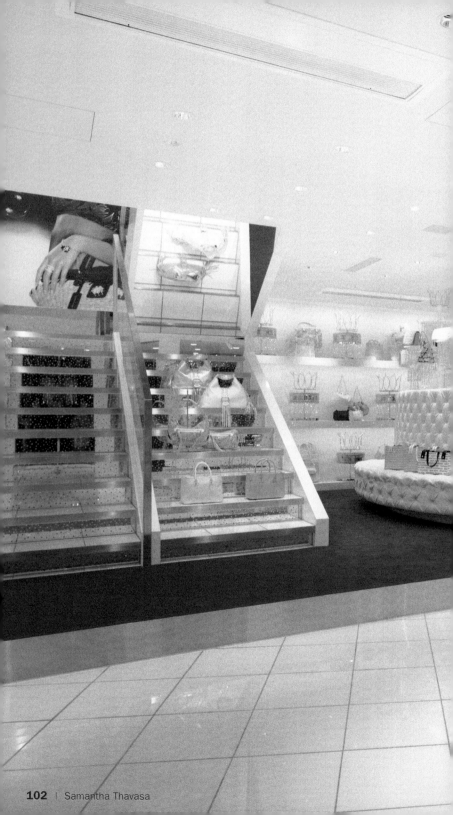

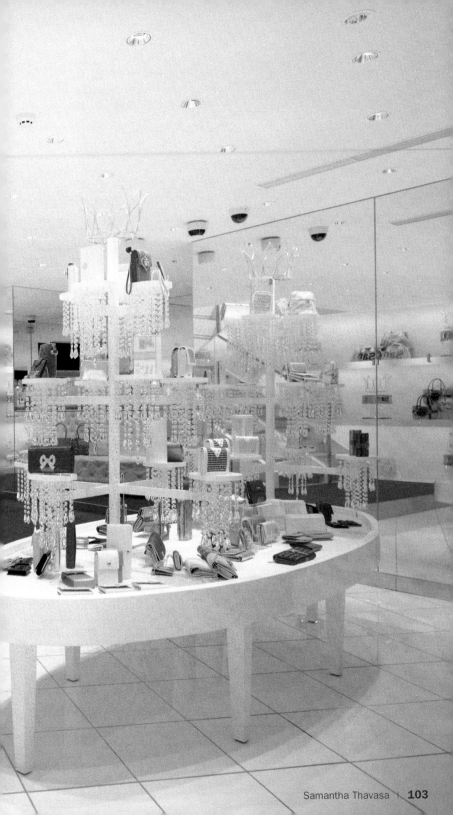

Sony Qualia

Design: Curiosity

Sony Bldg., 5-3-1 Ginza | Tokyo 104-0061 | Chuo-ku
Phone: +81 3 3573 2563
www.sony.net/SonyInfo/QUALIA
Subway: Ginza
Opening hours: Mon–Sun 11 am to 7 pm
Products: Sony's Qualia collection of high technology products
Special features: High-end Sony products in one of the most popular buildings of
Ginza neighborhood

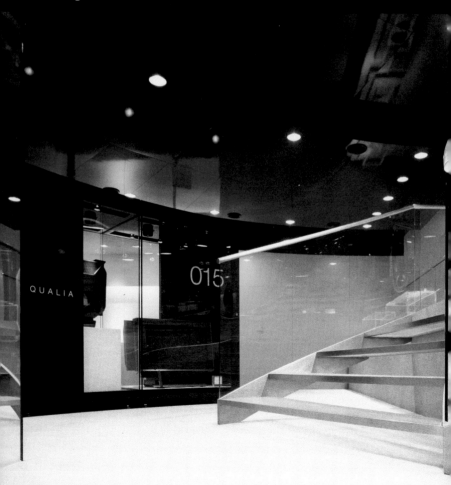

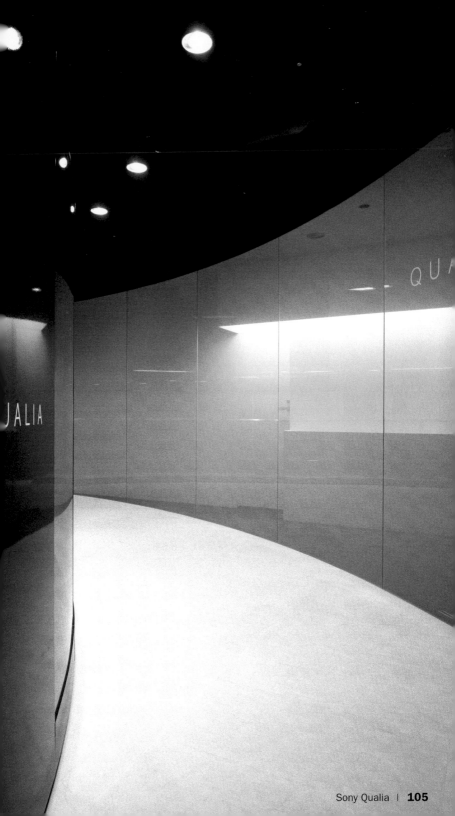

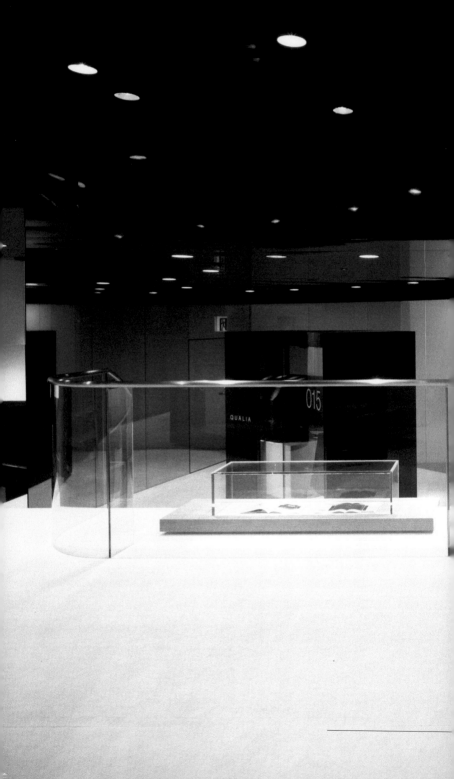

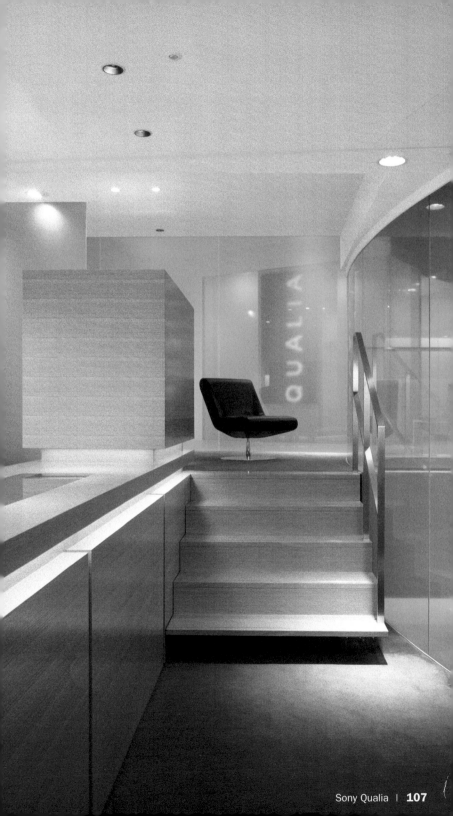

South Drive

Design: Ichiro Nishiwaki

4F, Shinjuku Myroad, 1-1-3 Nishi Shinjuku I Tokyo 160-0023 I Shinjuku-ku
Phone: +81 3 3349 5611
www.tamaya.co.jp
Subway: Shinjuku
Opening hours: Mon–Sun 11 am to 9 pm
Products: Fashionable sports items
Special features: The decoration with mirrors and the curved wall make the stor
look much bigger

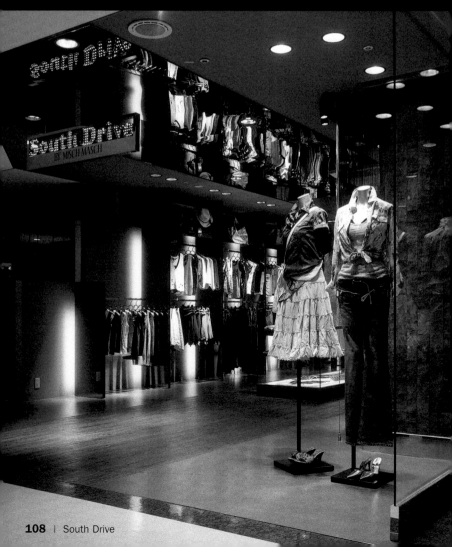

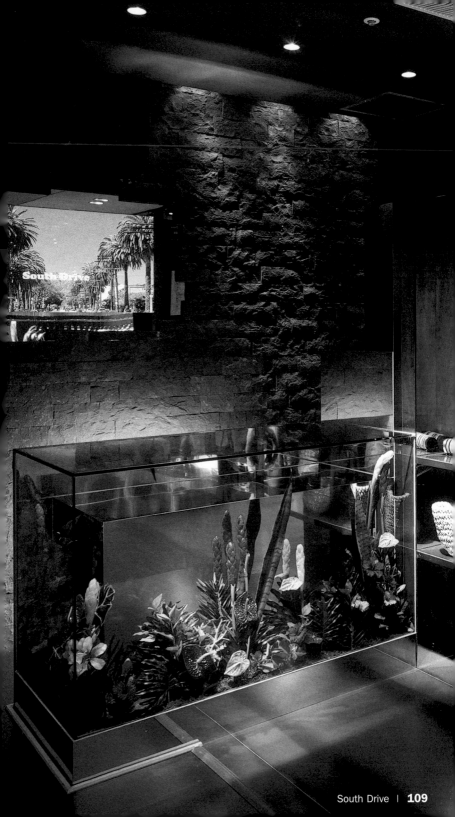

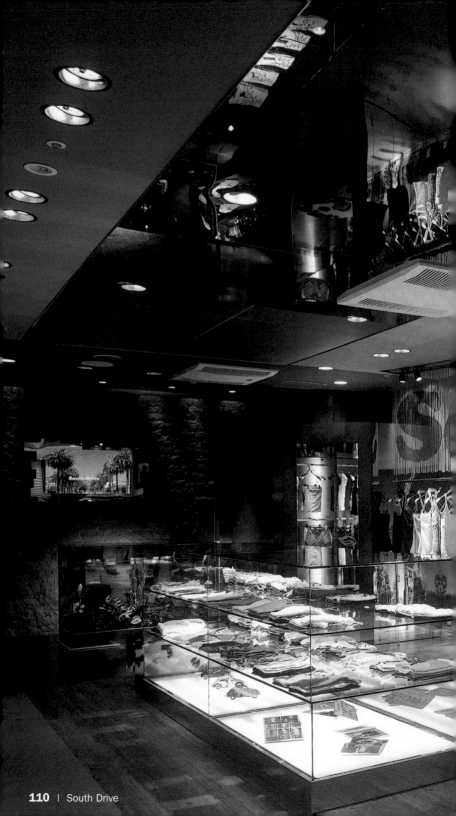

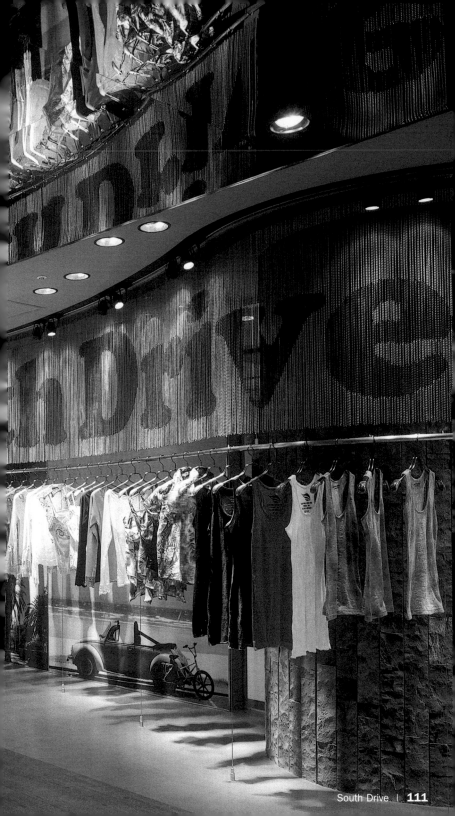

Tag Heuer

Design: Gwenael Nicolas, Curiosity

5-8-1 Jingumae I Tokyo 150-0001 I Shibuya-ku
Phone: + 81 3 5467 4881
www.tagheuer.com
Subway: Omotesando
Opening hours: Mon–Sun 11 am to 8 pm
Products: Luxury watches
Special features: The combination of warm and cool materials such as wood
and glass afford this space an air of sophistication

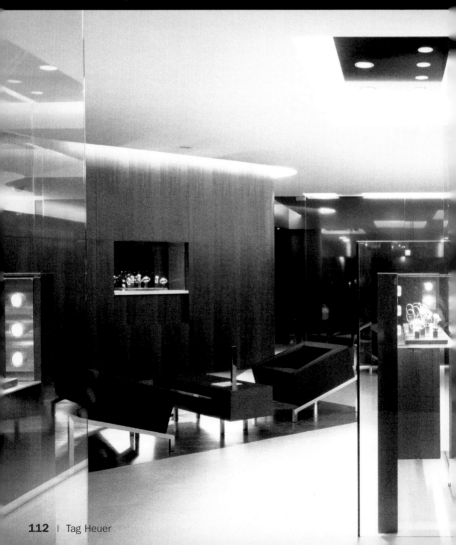

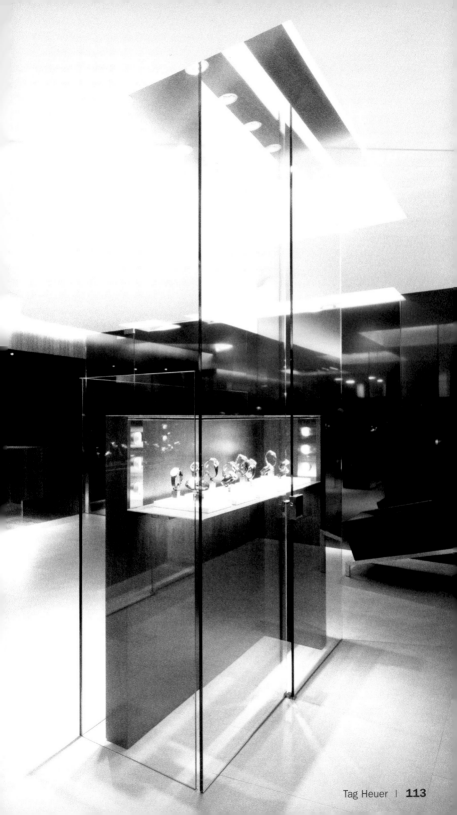

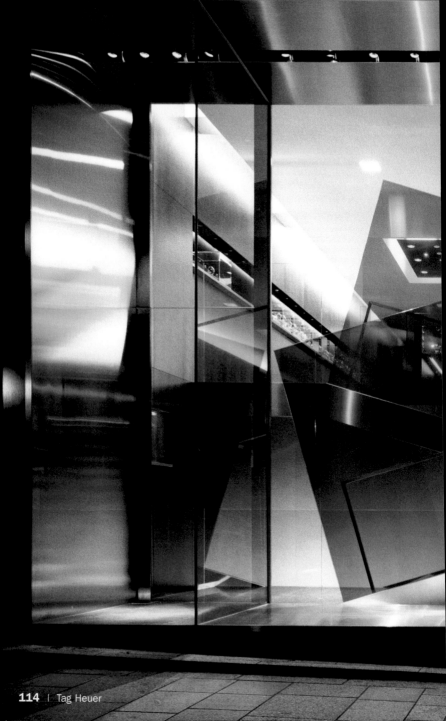

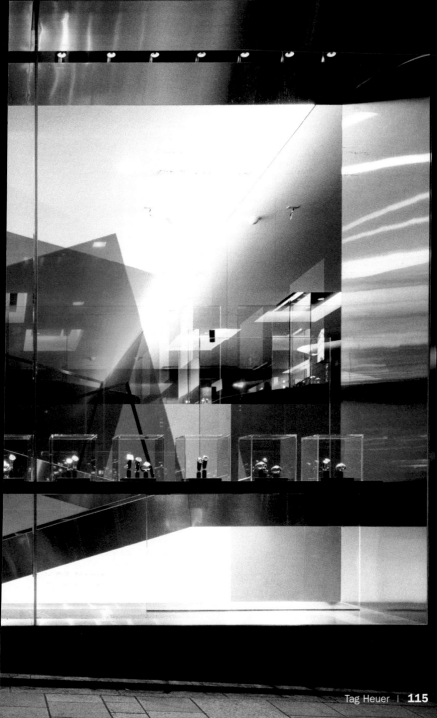

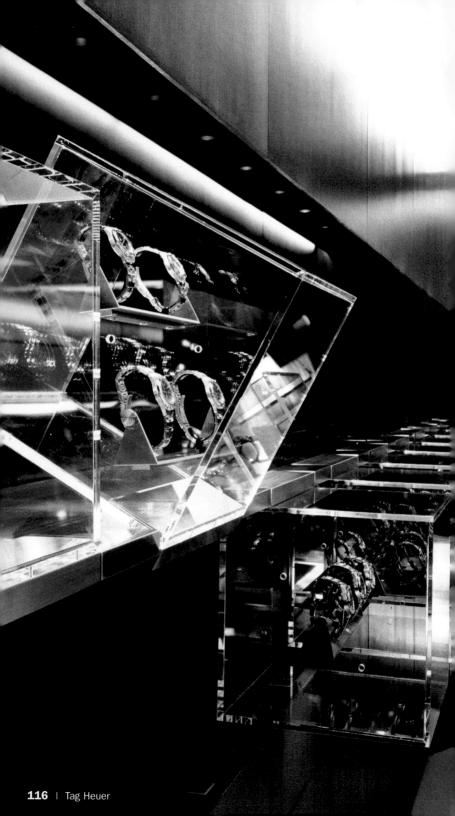

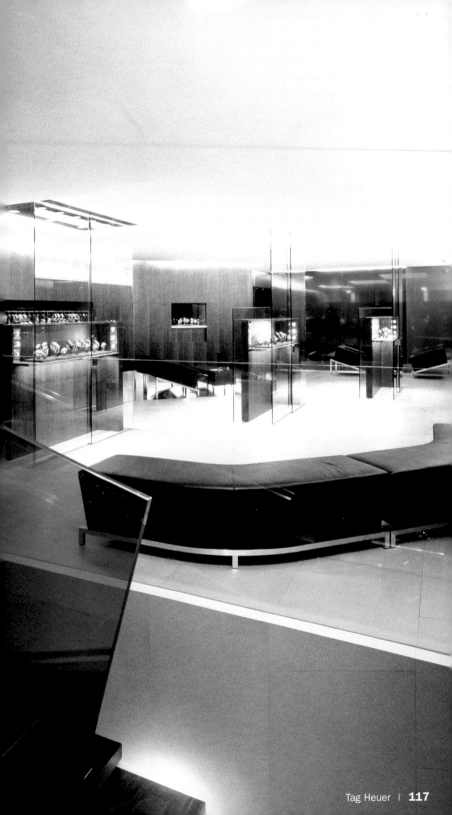

Tod's

Design: Toyo Ito

5-1-15 Jingumae | Tokyo 150-0001 | Shibuya-ku
Phone: +81 3 6419 2350
www.tods.com
Subway: Omotesando
Opening hours: Mon–Sun 11 am to 8 pm
Products: Shoes, clothes and top-class complements
Special features: Toyo Ito's fantastic building is without par in the world

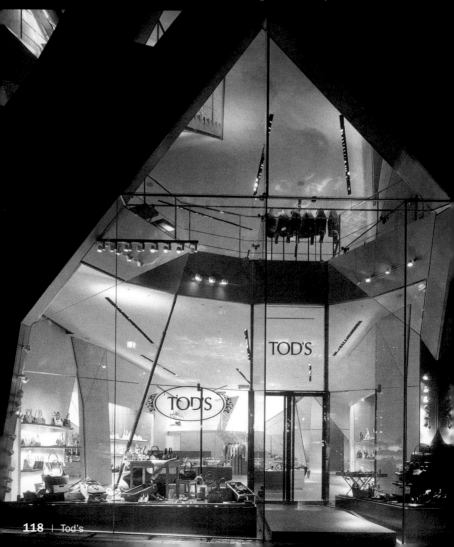

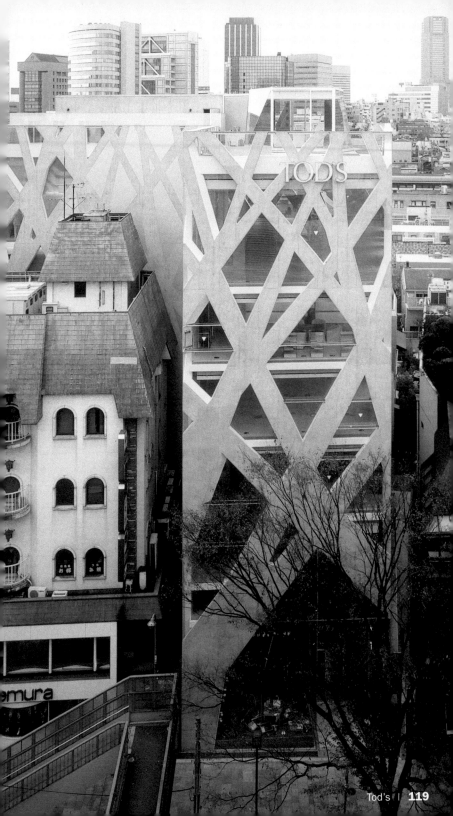

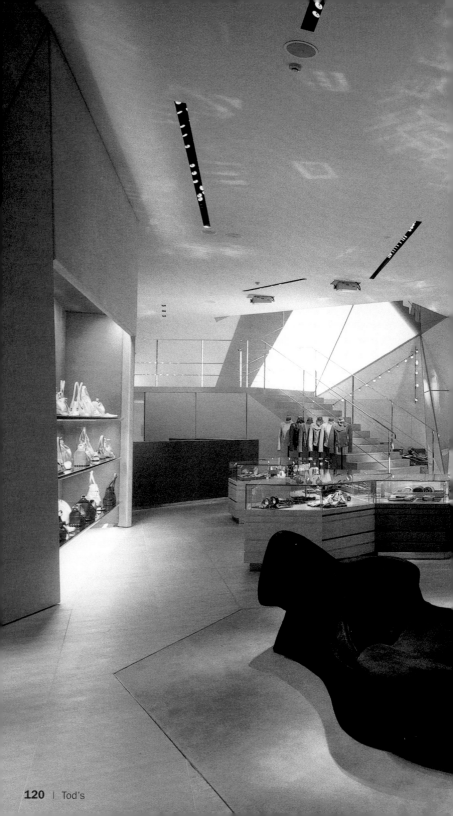

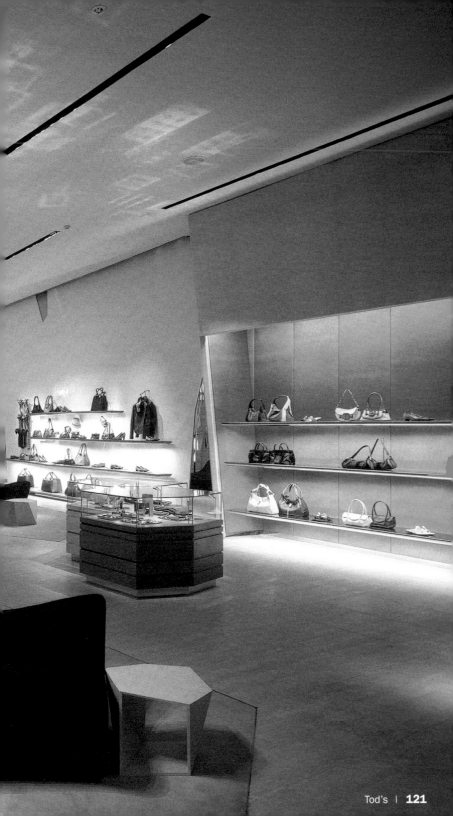

United Bamboo

Design: Vito Acconci

20-14 Sarugaku-cho I Tokyo 150-0033 I Shibuya-ku
Phone: +81 3 6415 7766
www.unitedbamboo.com
Subway: Ebisu
Opening hours: Mon–Sun 11 am to 8 pm
Products: Women's clothes, bags, shoes
Special features: The designs of Vito Acconci are currently the most acclaimed
in the world

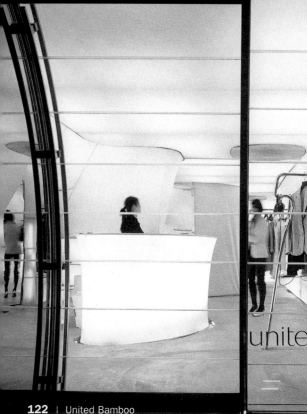
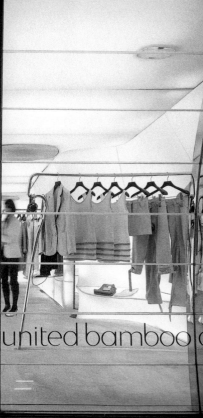

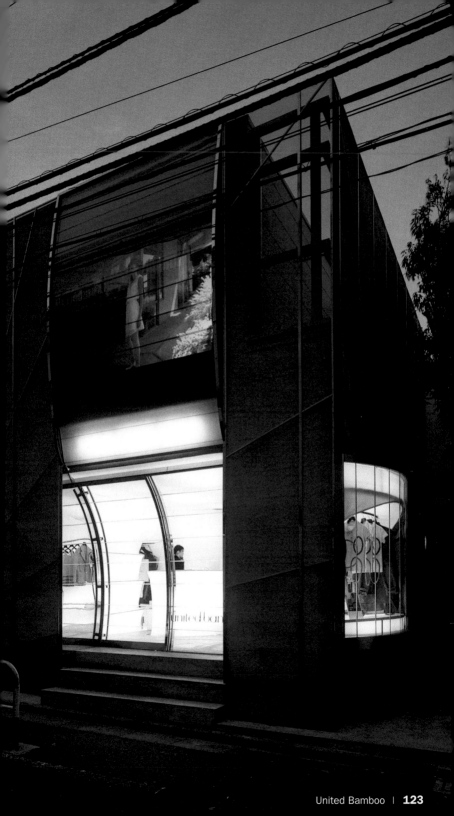

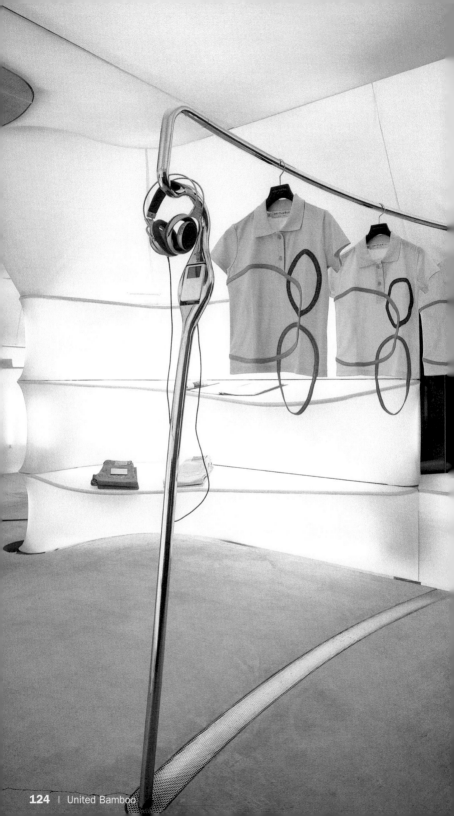

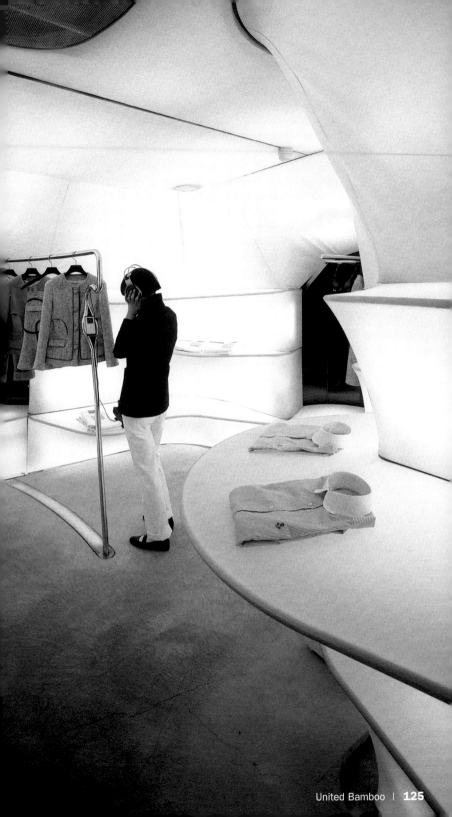

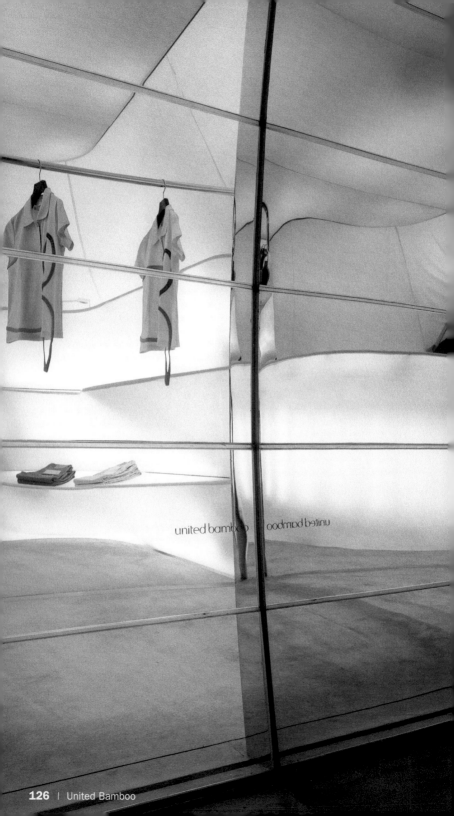

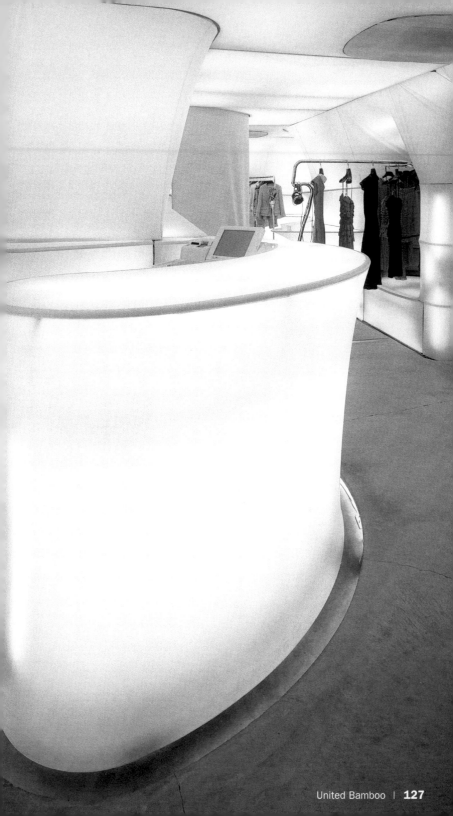

Y's

Design: Ron Arad

Roppongi Keyakizaka-Dori, 6-12-4 Roppongi | Tokyo 106-0032 | Minato-ku
Phone: +81 3 5413 3434
www.yohjiyamamoto.co.jp
Subway: Roppongi
Opening hours: Mon–Sun 11 am to 9 pm
Products: Men's and women's clothes
Special features: A unique store in keeping with the Y's collections

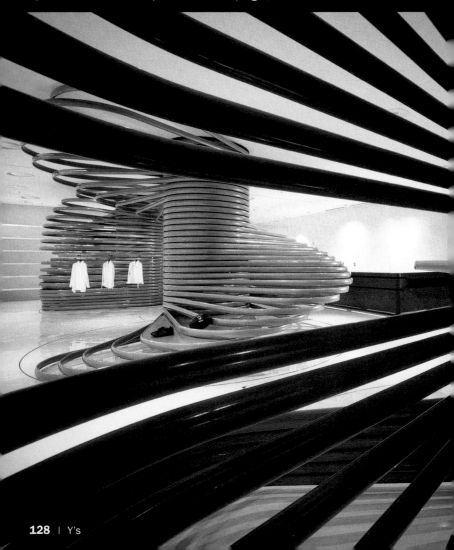

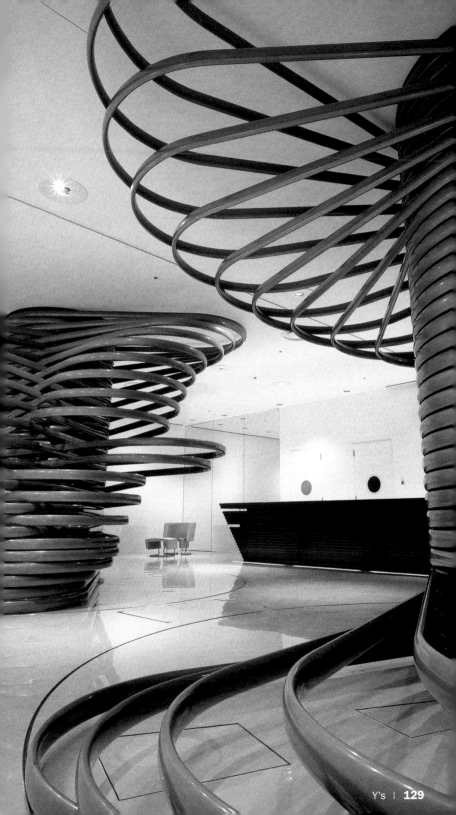

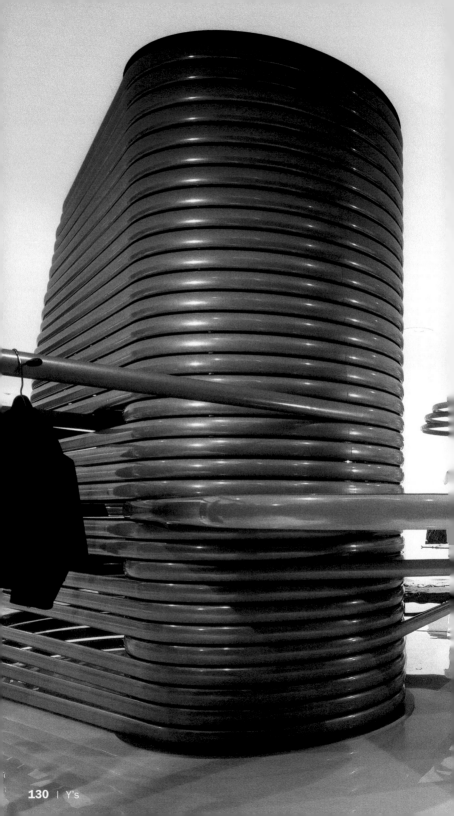

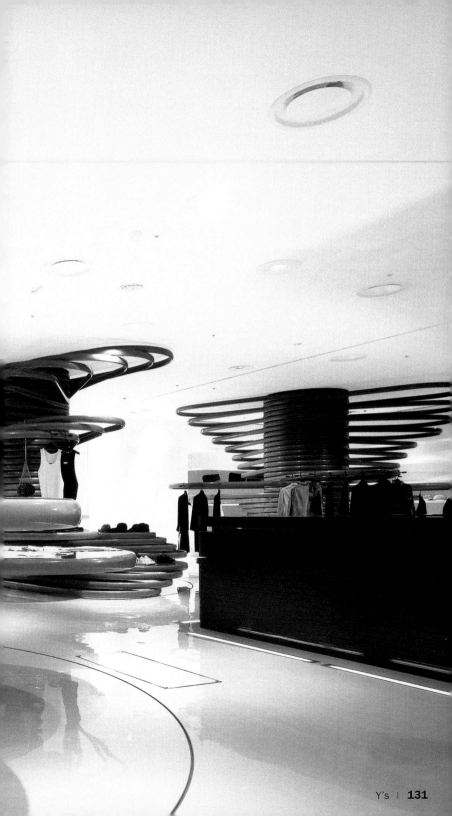

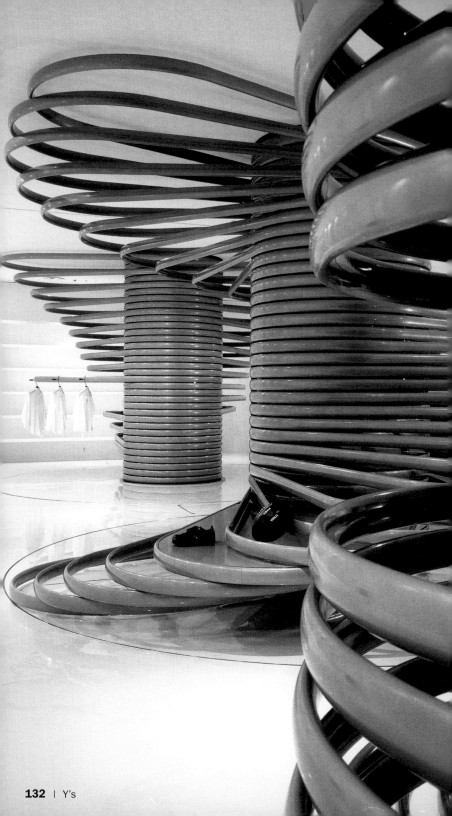

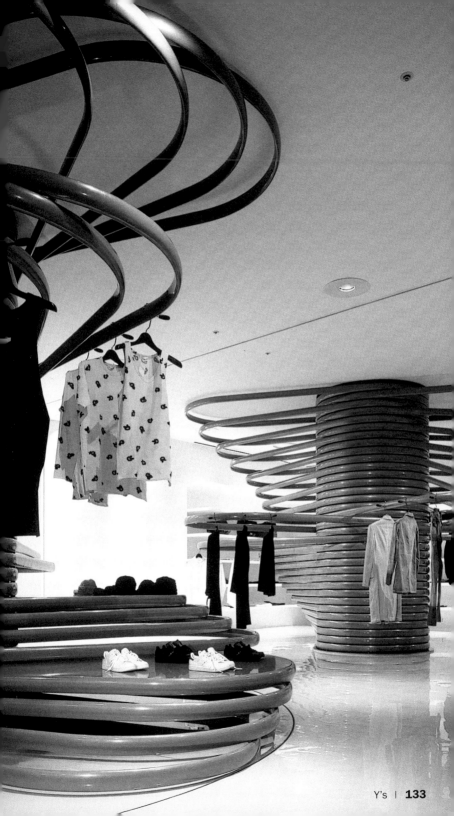

10

24 Shinjuku

Shinjuku Gyoen Garden

Meiji Shrine Outer Garden

Yoyogi Park

Jingumae

18

5

Aoyama-Dori A

7

26

11 15

4

8

2 22

19

Aoya
Ceme

25

Minami-Aoyama

SHIBUYA-KU

Tamagawa-Dori Ave

27

1

134

CHIYODA-KU

3

Marunouchi
20

Nihombashi

14

Showa-Dori Ave

Ginza
17

CHUO-KU

9

13 **16**
23
12

Harumi-Dori Ave

Sakurada-Dori Ave

28
bongi

21

NATO-KU

Shiba
Park

Shibadaimon

TOKYO
BAY

135

COOL SHOPS

Size: 14 x 21.5 cm / 5 ½ x 8 ½
136 pp
Flexicover
c. 130 color photographs
Text in English, German, French, Spanish and Italian

Other titles in the same series:

ISBN
3-8327-9073-X

ISBN
3-8327-9070-5

ISBN
3-8327-9120-5

ISBN
3-8327-9121-3

ISBN
3-8327-9

ISBN
3-8327-9071-3

ISBN
3-8327-9022-5

ISBN
3-8327-9072-1

ISBN
3-8327-9021-7

ISBN
3-8327-9

To be published in the same series:

Amsterdam
Dubai
Madrid
Miami

San Francisco
Shanghai
Singapore
Vienna

teNeues